IMAGES
of Rail

MANHATTAN'S
LOST STREETCARS

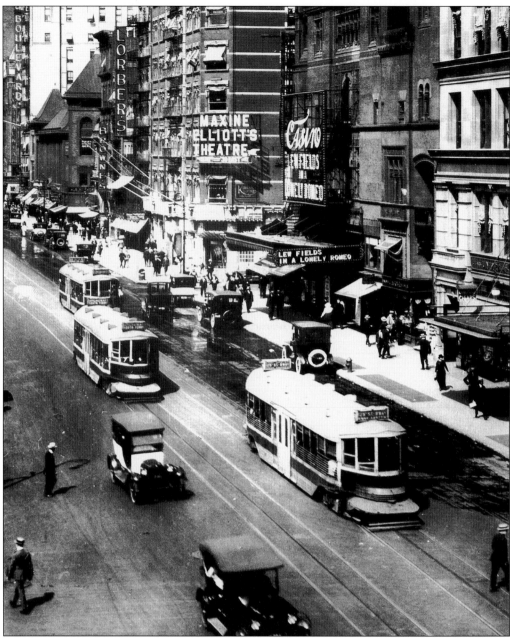

These strange-looking streetcars were the New York Railways' answer to the then current women's fashion of restraining hobble skirts. The extremely low center entrance allowed women to enter cars quickly. This scene is Broadway and 39th Street around 1920.

IMAGES
of Rail

MANHATTAN'S
LOST STREETCARS

Stephen L. Meyers

ARCADIA

ISBN 0-7385-3884-1

Published by Arcadia Publishing
Charleston SC, Chicago IL, Portsmouth NH, San Francisco CA

Printed in Great Britain

Library of Congress Catalog Card Number: 2005926839

For all general information contact Arcadia Publishing at:
Telephone 843-853-2070
Fax 843-853-0044
E-mail sales@arcadiapublishing.com
For customer service and orders:
Toll-Free 1-888-313-2665

Visit us on the internet at http://www.arcadiapublishing.com

CONTENTS

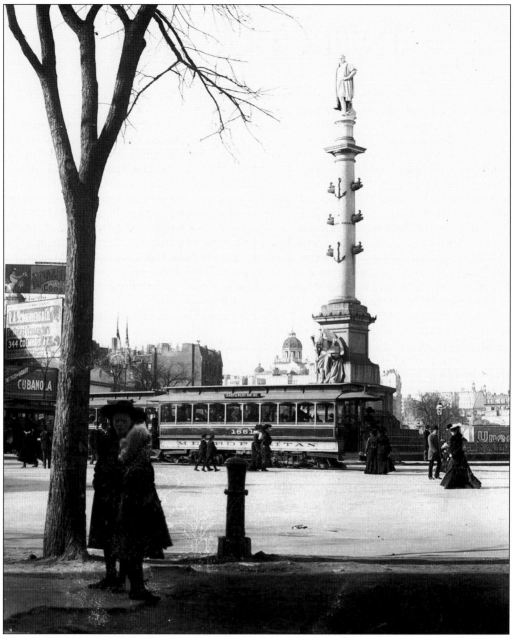

This *c.* 1906 view of Columbus Circle evokes a time "when our hearts were young and gay."

INTRODUCTION

"Lost" streetcars? Some streetcars were over 40 feet long, over 8 feet high, and more than 9 feet wide. So how could such an entity be considered lost?

Like all too many American items, things can fall through the cracks, even while in plain sight. Manhattan's street railways are a major case in point. At one time, well over two dozen street railways plied the streets and avenues of Manhattan while hundreds lived only as "paper" companies, yet today barely a handful are even recollected. The long-running Third Avenue Railway and the doughty Queensborough Bridge trolley might come to mind because they "hung around" until the mid-1950s. But each of those previously mentioned multitudinous entities had its own history and personality. Yet the stories of such companies as the schizophrenic New York and Harlem, the symbiotic Eighth and Ninth Avenues Railway, and even the high-profile New York Railways are lost in the mists of America's industrial history. They, and many other of Gotham's street railways, were instrumental in making New York City's center, Manhattan, the heart of America's most successful urban complex. This volume will attempt to identify and follow the rise and fall of a business that once had well over 470 miles of tracks, carrying millions of passengers daily and then virtually disappearing without a trace.

The logical question would be, why did they get lost? The answer is quite complicated but generally falls into three major categories.

First, they had value and were consolidated into larger systems, such as the Metropolitan Street Railway, which for about a decade, either owned or leased every streetcar company in the boroughs of Manhattan and the Bronx and even ran some lines in suburban Westchester County. During that period, the individual companies lost their corporate identity and operated under the name of the consolidated operating company.

Second, the companies built lines in areas where there was insufficient traffic to keep them solvent, so they went broke, were abandoned, and completely disappeared. An excellent example was the 28th and 29th Streets Crosstown Railway, which never should have been built and, early on, sunk without a trace.

Third, the companies, usually the consolidated systems, died a natural economic death because they had outlived their usefulness. Sometimes because of a poor product: New York Railways, which in its death throes in the 1935–1936 period, were operating a fleet of streetcars designed in 1898, the newest of which was built in 1912, and the product was perceived as being old fashioned. And some never understood the strength of their competition, the subways and elevated rapid-transit lines. And finally, some expired because of political considerations, either real or manufactured. The plant of the Third Avenue Railway was reasonably modern, but the stated objective of Mayor Fiorello LaGuardia was to rid the city of streetcars. And, by using their franchises as leverage, he did.

This book will attempt to explain the rise and fall of the street railway industry in prose and picture. Some of the photographs are old and quite rare, but all reflect the specific ways in which the streetcars of Manhattan impacted on the city's development. You might be surprised.

THE BEGINNINGS

The term MABSTOA probably means little to the average New Yorker, but it is an acronym for New York City's major bus-operating entity, the Manhattan and Bronx Surface Transit Operating Authority. They run the buses seen on the streets of Manhattan and the Bronx. And while you might recognize the route numbers on the buses, such as M-104 and M-15, you might be surprised to hear that the M-104 line was preceded by the 42nd Street, Manhattanville and St. Nicholas Avenue Railway (founded in 1878), and the M-15 is the successor to the Second Avenue Railroad (franchised in 1852). These are just two of the dozens of street railways that once covered Manhattan.

This volume will attempt to explain the origins and to track the economic lives of those surface railways that helped to form the traffic patterns of Manhattan's streets and explore those twists and turns of fate that changed the complexion of street traffic. But first we will draw some guidelines for this book. Although officially New York City consists of five boroughs, it is usually presumed that when the term "New York City" is used, it refers only to Manhattan. As a matter of fact, for years streetcars and buses coming over bridges from other boroughs into Manhattan carried "New York" on their destination signs.

Manhattan is an island approximately 12½ miles long and about a mile and a half in width at its widest point. It was settled by the Dutch in the 1600s and lost to the British less than a quarter of a century later. The city was originally settled at its southernmost point, South Ferry and Bowling Green, and extended to the north, spreading out to its East River and North (Hudson) River boundaries as it grew. Around 1830, it became the major *entre port* for immigrants to the New World. The arrival of the immigrants quickly changed everything.

New York was suddenly overwhelmed by the waves of these new settlers. The southern triangle of Manhattan was inundated by the new populace and strained at the seams. Housing became overcrowded, and the twin curses of crime and disease followed. For the next 75 years, this situation festered, but a strange partial remedy came out of this chaos. It was one of those unexpected inventions that changed forever the format of American cities. The discovery was the railroad—not only the steam-powered railroads that opened up the country but the horse-drawn variety as well. It proved the concept that a city could spread outward and still be a single political, social, and economic entity.

On April 25, 1831, the nation's first streetcar company, the New York and Harlem Railroad, was franchised to run essentially between two New York areas, the original core city on lower Manhattan and the suburb of Harlem, miles to the north. The line was to operate north of 23rd Street to "any point on the Harlem River between the East bounds of the Third Avenue and the West bounds of Eighth Avenue." The motivating power was to be "by the power and force of steam, of animals, or any mechanical or other power, or of any combination of them which said company may chose to employ." Said company opted for steam power, but the city decided that it did not want steam trains running through downtown city streets, so it decreed that animal power was to be used on the lower portions of the line.

The franchise was quickly amended to allow the company to operate south of 23rd Street and, in increments, finally to terminate at the lower end of what later became Park Row. At various intervals, the line was permitted to extend northward simultaneously via both Park (Fourth) Avenue and Madison Avenue to the Harlem River, with the Park Avenue line finally terminating at Chatham, a suburb in Duchess county.

One of the ultimate intermediate destinations was the then far uptown railroad terminal, Grand Central Depot (later Terminal) at 42nd Street. Since the New York and Harlem was franchised as a major railroad entering Manhattan Island proper, under its frequently amended franchise it was permitted to move both its steam railroad passenger and freight cars by horse power to its "downtown" terminal at Prince Street. As it developed into both a major steam railroad (eventually joining with the Vanderbilt-controlled New York Central and Hudson River group to run long-distance steam trains and as a major local horsecar line), the lines of operation started to formalize and separate. While freight and some passenger units directly entered the Grand Central complex, a passenger spur went west on 42nd Street to Madison Avenue and then headed north. This became the Fourth and Madison Avenue streetcar line. Until the end of street railway operation, the underlying description of the street railway service was officially listed by the railroad as "the traction division of the New York and Harlem Railroad."

The new railway operated the first locally available fast service between two separate geographic sections of New York and was a harbinger of things to come. For the first time, it was possible to disperse living areas and permit workers to move easily from home to business location, and this would have a major effect on the ultimate development of New York City.

One

THE FRANCHISES

The most important operating document was the line's franchise. A franchise was the contract between the municipality and the street railway company spelling out the rights and privileges for operating street railway services. A franchise would specify the route, the number of tracks, the fare system, and the duration of the contract. Originally in Manhattan, the franchises were not considered to have much value, and so they were bestowed in perpetuity upon political cronies or those entrepreneurs who were daft enough to think they could make money under them. So the city did not ask for a franchise fee or a percentage of the gross profit. However, once it was realized that there was real money to be made, the game changed. In those days, the New York City government's favors were practically for sale to the highest bidder, usually "off the table." This kept the game open only to bidders who were connected or rich, so everybody was happy. But by the law of increments, the city soon learned that it could get other concessions from the street railway companies.

For instance, since the horsecars ran on unpaved streets, it was obvious that the horses' hooves would tear up the street between the rails; therefore, franchises were drawn that would require the surface railway to pave the space between the tracks. That sounded fair at first, but then the horsecar teams were doubled on some lines, so the city ruled that two feet on either side of the rails would have to be paved because they now used a larger portion of the street. That was pushing it a bit, but the city had barely started. It was then ruled that since the streetcars were using public property for their own profit, it was incumbent upon them to clear the streets of snow. But the game had much further to go for the city to squeeze additional money out of the franchisee. The most galling item came after the lines replaced the horses with electricity. At that point, the operators said that since their prime mover (electricity) did not impact on the paving as the horse formerly did, they should be excused from the onerous paving requirements. The city fathers, recognizing that they had a good thing going, decided to keep the paving requirement in. This approach to indirect taxation was not limited to New York but became standard throughout the United States and impacted on the revenue of every streetcar and trolley operation so taxed until the end of rail service. And, oh yes, it was general municipal policy for the franchise to require that policemen and firemen ride free.

Since the franchise was, in fact, "the only game in town" to an aspiring street railway magnate, it became a life-or-death proposition for the would-be operator. New York City quickly recognized that they had a good thing going and really started playing the game. Under the so-called Cantor Act, New York's local government flung open the franchise gates by stating

that after a certain date, all franchises would be open to bidding with the winner to be the company giving the highest percentage of gross revenue. This set up one of the wildest scenes of bidding ever seen in any sector of the business world. Two "paper" companies (not owning tracks or equipment) started bidding on a yet unbuilt route in the Bronx. A third company had wisely dropped out of the bidding when the franchise fee topped four percent of the gross. The two remaining companies, the People's Traction Company and the New York Traction Company, bitter rivals, got into a bidding contest. The fee percentage went up by fractions until the People's company jumped their offer to seven percent of their gross revenue. At this point, things got out of control. The New York Traction group decided that they were not going to be left out, so they topped their bid by an additional one-half percent. At this point, either the two bidding agents had a liquid lunch together and decided to make some history or they figured that it was worth the cost just to keep the other company out. The subsequent bidding then became giddy with the pot going in stages to 100 percent of the gross, to 1,000 percent, to 2,000 percent to a final bid of 6,975.16 percent of the gross revenue! A restraining order was placed on this farcical scene, and after more than a year of litigation, People's Traction Company finally got the franchise for the "bargain" price of 97 percent for the first five years and 95 percent for each year thereafter. They never built their line.

There was one final kicker in the franchise game as played by New York. Some franchises were classified as perpetual, which meant that they could not be cancelled, ever. So when the Third Avenue Railway System conglomerate wanted to renew their fixed-date franchises, the city said, "Okay, we'll renew your fixed-date franchises—but we want those perpetual franchises to be revised so that we can cancel them at will. And, oh yes, we want you to motorize all of your streetcar lines within ten years—or else." They signed, and they motorized. In a moment of supreme irony, at the time this solution was resolved, the Third Avenue was busily engaged in constructing new, modern trolley cars for those specific lines.

And now, on with the show.

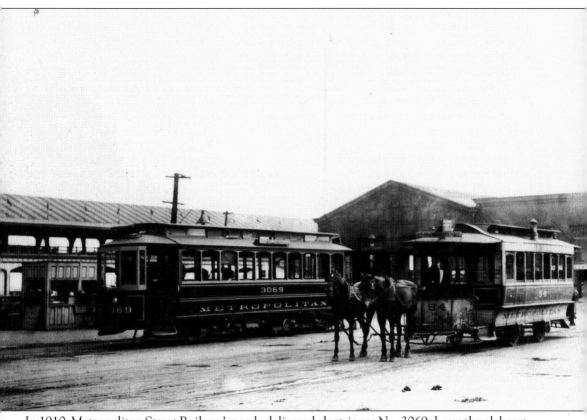

In 1910, Metropolitan Street Railway's newly delivered electric car No. 3069 shares the elaborate East 23rd Street terminal with rather nondescript horsecar No. 54.

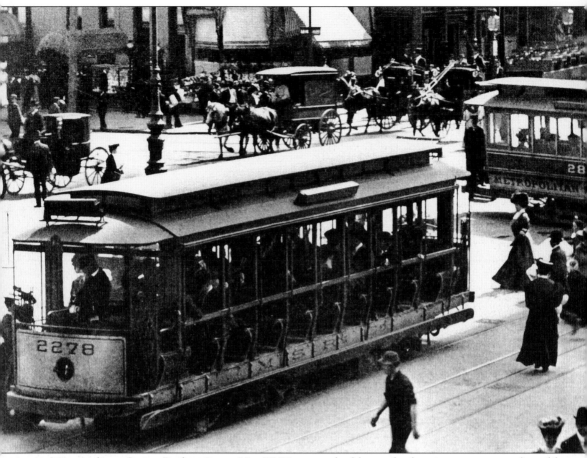

Metropolitan Street Railway's car No. 2278 was a double-truck electric open car and could seat 60 passengers. Note the horse-drawn carriage in the left background and closed horsecar No. 289 across the back.

Third Avenue Railway's West Belt Line served the Hudson River steamship piers. In this view, storage battery car No. 1231 is passing the pier of the famed Iron Steamboat Company on a hot July day in 1914, having just dropped off a group of Rockaway Park–bound steamboat passengers. (Courtesy Vincent Seyfried collection.)

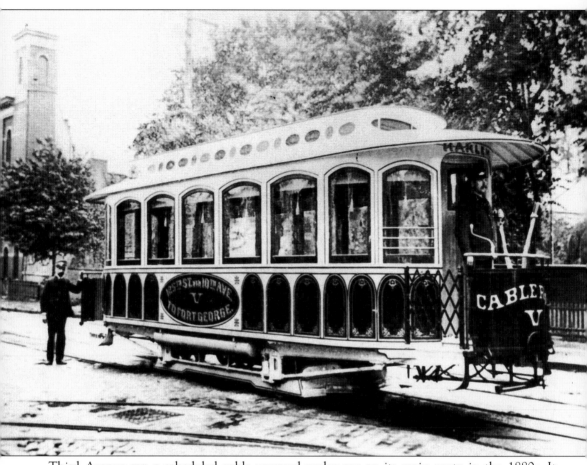

Third Avenue ran a scheduled cable-powered parlor car on its main route in the 1880s. It sported velvet covered seats and charged a heavy 25¢ extra fare.

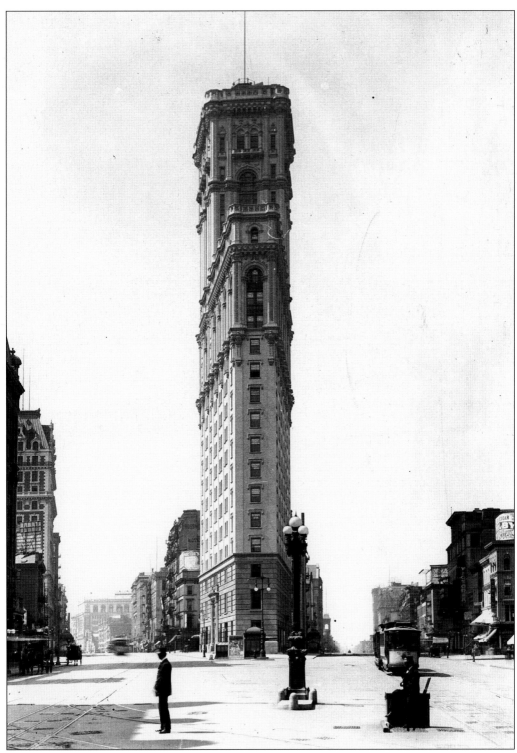

Longacre Square had recently been renamed Times Square when this 1903 photograph was taken. Note the switchman and his manually operated switching device to the lower right.

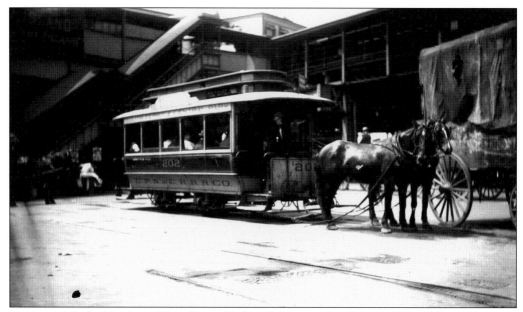

In Central Park, North and East River Railroad's five-window horsecar No. 202 sports a rare double-deck "Bombay roof" as it waits patiently in one of Manhattan's famed traffic jams while serving the West Belt Line.

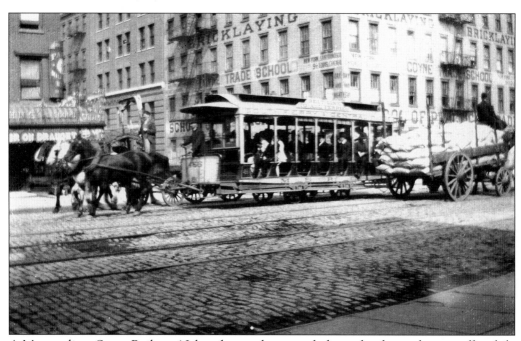

A Metropolitan Street Railway 10-bench open horsecar dodges other horse-drawn traffic while in Belt Line service.

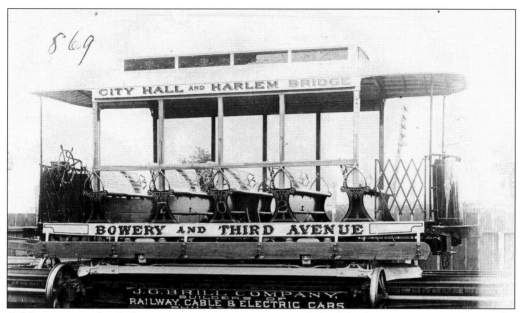

Cable cars were divided into two major types: grip cars (which had an apparatus to engage the cable) and trailers (which did not). Car No. 702 was a grip car.

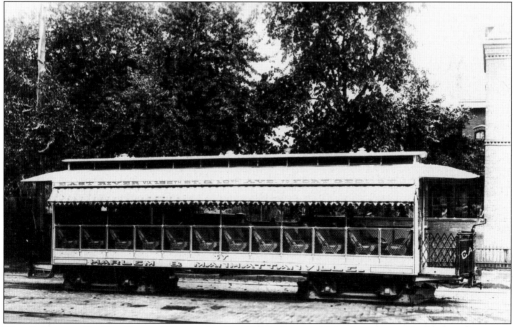

Third Avenue Railroad's car W ran on the 125th Street–10th Avenue cable line and was an experiment. It was long, had two trucks (wheel sets), was a grip car, and could be operated in either closed or open configuration. It is shown operating open. It was never duplicated.

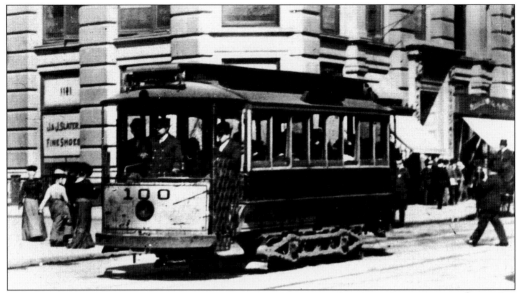

The Metropolitan Street Railway's eight-window No. 100 is shown on the Broadway line. This was an early electric car and carried both a motorman and a conductor.

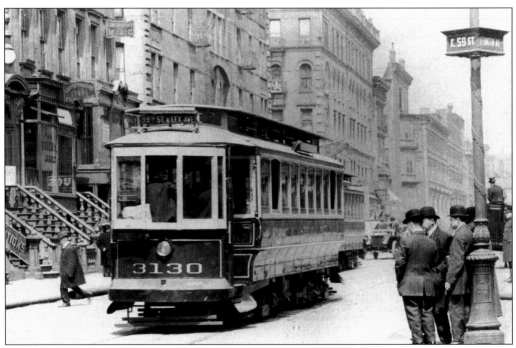

Closely watched by derby-wearing dandies, open platform New York Railways car No. 3130 is at the intersection of 59th Street and Lexington Avenue, home address of Bloomingdale's, around 1913.

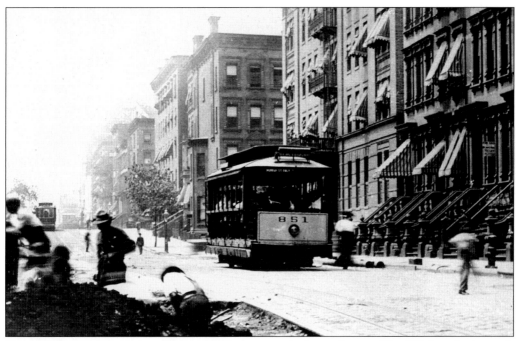

Open cars came in two sizes. This *c.* 1913 photograph shows that car No. 851 is a single-truck version and carried 50 passengers.

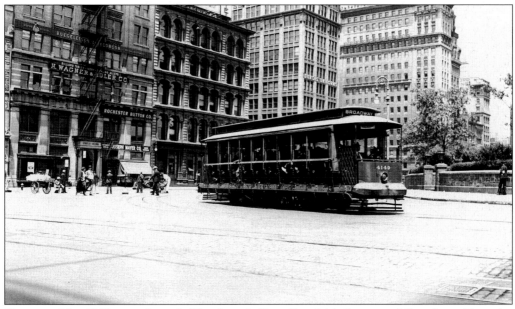

Open car No. 4149 runs through "Deadman's Curve" at 14th Street and Broadway. Note the safety bar, designed to keep passengers from toppling out of the moving car. On the entering side of the car, the bar was kept raised.

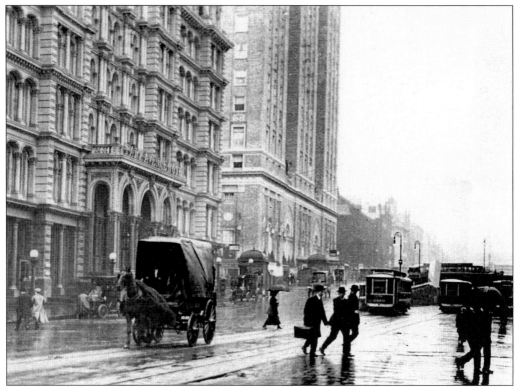

Shown here is the south end of Murray Hill Tunnel (Park Avenue South between 42nd Street and 33rd Street). It was originally built to move New York and Harlem Railroad steam cars to lower Manhattan terminals.

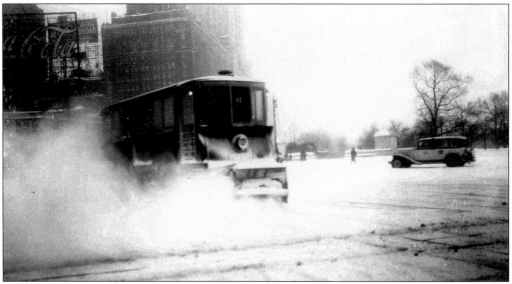

A snow sweeper on the Third Avenue Railway's Broadway route does its job at Columbus Circle in January 1936. The cleared tracks in the foreground were the company's 59th Street crosstown line.

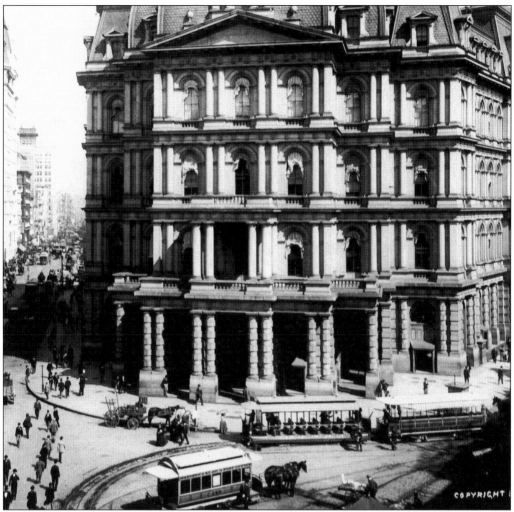

New York's main post office, located at the intersection of Broadway (left) and Park Row (right), is a major terminal for horsecars and cable cars in this 1894 vignette of lower Manhattan.

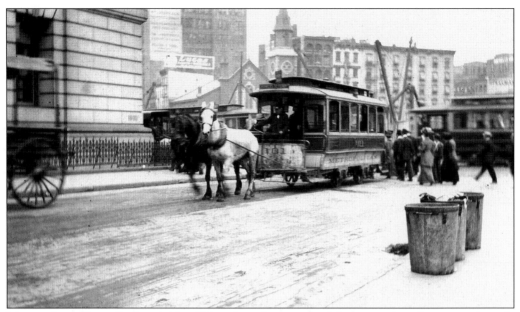

Metropolitan Street Railway's No. 101, a short (six-window) horsecar, threads its way through downtown Manhattan in 1902.

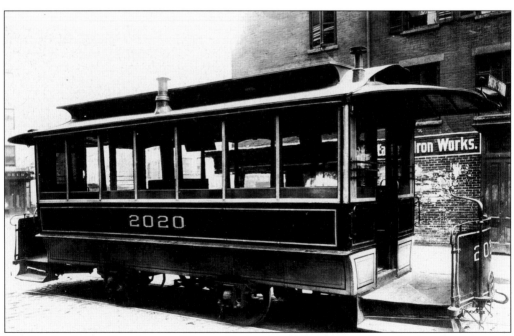

The Dry Dock, East Broadway and Battery Railroad used horsecars such as this one on its animal-powered lower East Side lines. Note the chimney, a singular sign of creature comfort on these cars, which at least had winter heating. Cars in this series were later converted into the Third Avenue Railway's first set of experimental storage battery cars.

Horsecar lines needed work equipment. This snowplow helped open New York's snowy streets, compliments of the then Third Avenue Railroad.

A residue from operating horsecars was the unending collection of horse droppings. Local farmers purchased huge quantities, which were transported in animal-propelled vehicles like this.

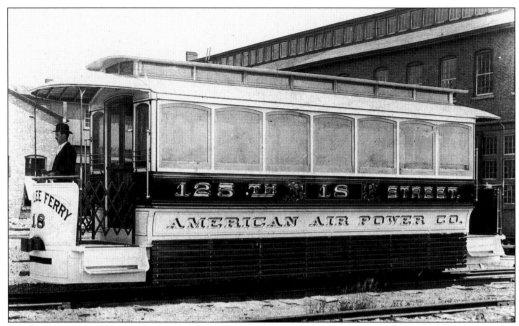

In its unending quest for something other than animal power, the Third Avenue Railroad commissioned the Hardy Compressed Air Company to build, in conjunction with the American Air Power Company, an experimental streetcar propelled by compressed air. Tried out on the line's 125th Street route, it was not a success.

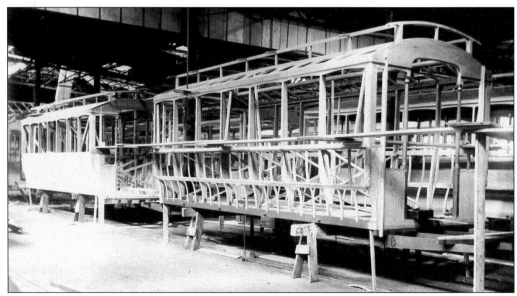

When the Third Avenue Railway realized in 1910 that they needed to replace animal power with battery power, they had their team of highly skilled woodworkers construct the first series of standard storage battery cars, shown here under construction.

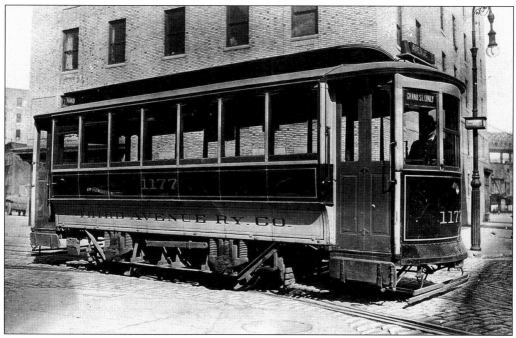

The Third Avenue Railway System owned and operated the lower Manhattan network of the Dry Dock, East Broadway and Battery Railroad. Most of that company's horsecar lines were replaced by storage battery cars such as No. 1177, shown at Cherry Street and Corlears Street. The lower photograph shows how the batteries were placed within the cars. Every evening, this entire fleet's batteries had to be recharged for the next day's operation.

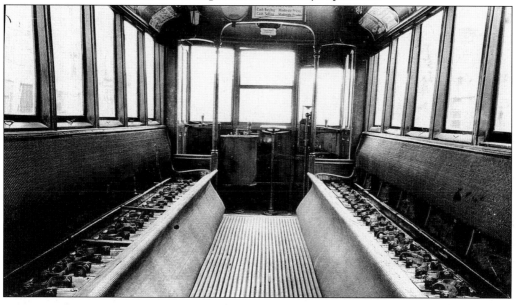

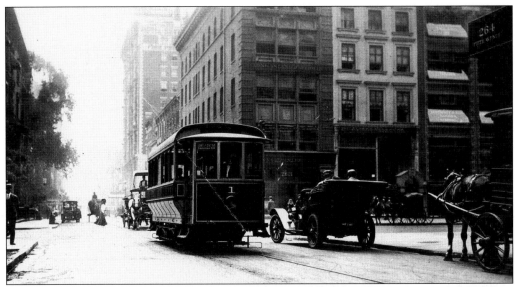

The 28th and 29th Streets Crosstown Railway was originally a heavy horsecar operation, but as Manhattan grew, the line's importance waned. The Third Avenue Railway tried experimenting with internal-combustion cars as a viable replacement. Car No. 1, built by the Wason Car Company in 1909, was originally gasoline powered.

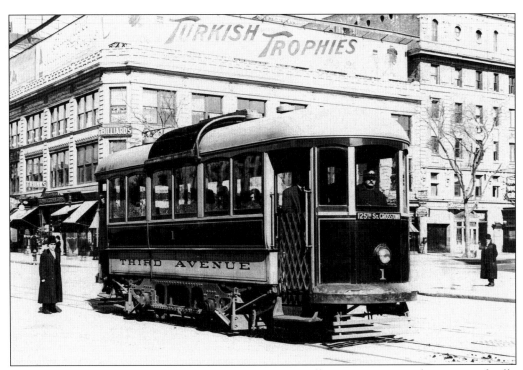

Car No. 1 was later rebuilt to this format but was equally unimpressive. The car was finally replaced by the Third Avenue's standard storage battery equipment.

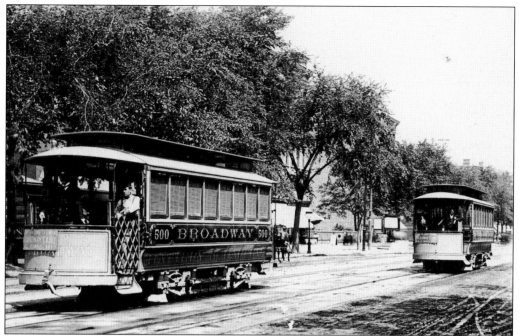

Metropolitan Street Railway's Lenox Avenue was one of their first cable lines and was also one of the first lines to be electrified (1896). In this view, car No. 500 is running on Lenox Avenue near 125th Street.

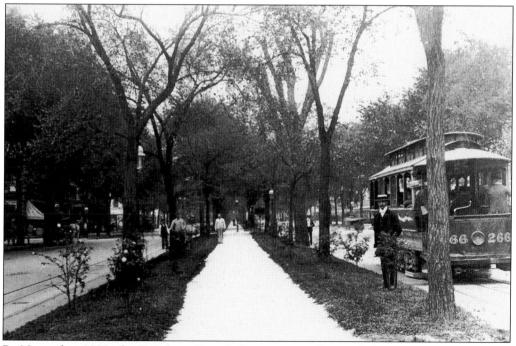

By November 1899, the Broadway Branch line was complete and electric cars were running. Car No. 266 is a former cable car originally used on the Third Avenue route but electrified for conduit service. Cars from this series were still in nonrevenue use as late as the 1950s.

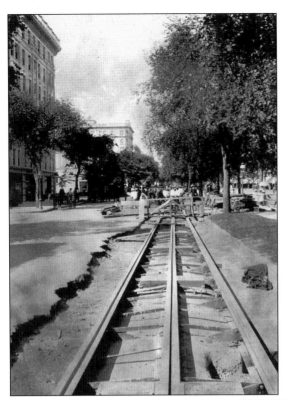

In 1899, the Third Avenue Railway was busy reconfiguring the heavy Broadway Branch line of the former 42nd Street, Manhattanville and St. Nicholas Avenue Railway to conduit electric operation. Shown is Broadway at 87th Street.

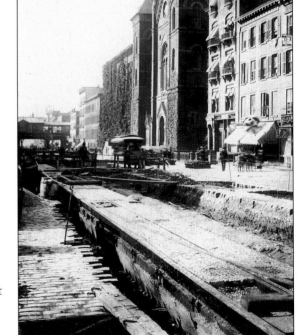

The same company's 42nd Street crosstown line was electrified in 1899. Here is a construction view looking west between Eighth and Ninth Avenues. The Ninth Avenue elevated is in the background.

Most of Manhattan's streetcars ran from electricity supplied by a conduit configuration between the rails. The conduit plow, shown here, had twin contacts that actually transferred the electricity into the cars' mechanisms.

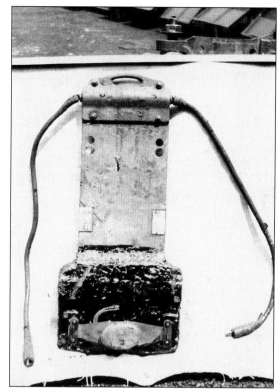

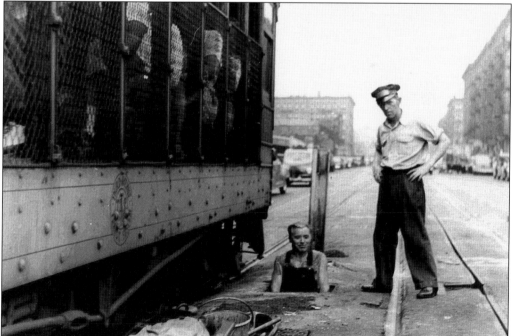

In some cases, the mode changed en route, and the plows were connected or removed by "pitmen" who performed their task from within tiny trolley pits alongside the tracks and occasionally came up for air.

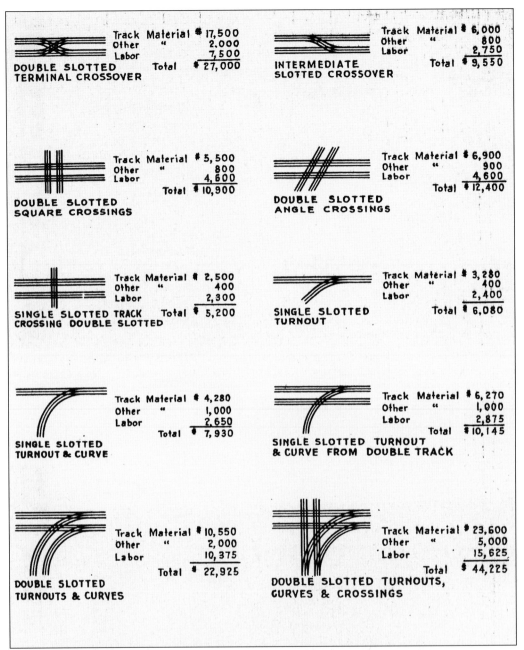

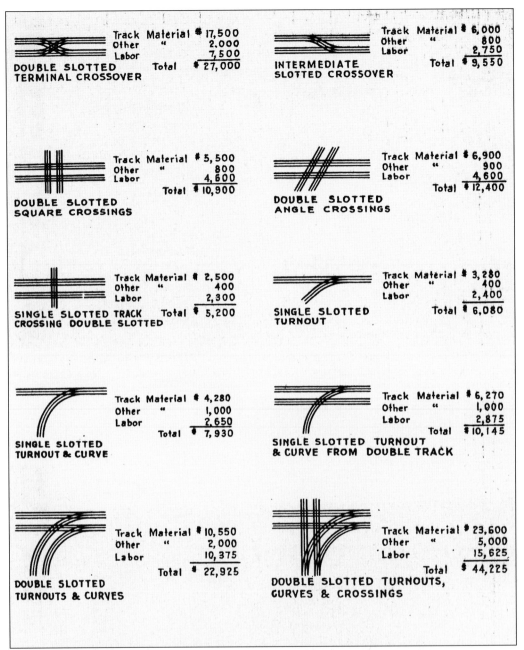

	Track Material	$ 17,500
DOUBLE SLOTTED	Other "	2,000
TERMINAL CROSSOVER	Labor	7,500
	Total	$ 27,000

INTERMEDIATE SLOTTED CROSSOVER — Track Material $ 6,000, Other " 800, Labor 2,750, Total $ 9,550

DOUBLE SLOTTED SQUARE CROSSINGS — Track Material $ 5,500, Other " 800, Labor 4,600, Total $ 10,900

DOUBLE SLOTTED ANGLE CROSSINGS — Track Material $ 6,900, Other " 900, Labor 4,600, Total $ 12,400

SINGLE SLOTTED TRACK CROSSING DOUBLE SLOTTED — Track Material $ 2,500, Other " 400, Labor 2,300, Total $ 5,200

SINGLE SLOTTED TURNOUT — Track Material $ 3,280, Other " 400, Labor 2,400, Total $ 6,080

SINGLE SLOTTED TURNOUT & CURVE — Track Material $ 4,280, Other " 1,000, Labor 2,650, Total $ 7,930

SINGLE SLOTTED TURNOUT & CURVE FROM DOUBLE TRACK — Track Material $ 6,270, Other " 1,000, Labor 2,875, Total $ 10,145

DOUBLE SLOTTED TURNOUTS & CURVES — Track Material $ 10,550, Other " 2,000, Labor 10,375, Total $ 22,925

DOUBLE SLOTTED TURNOUTS, CURVES & CROSSINGS — Track Material $ 23,600, Other " 5,000, Labor 15,625, Total $ 44,225

A page from a 1917 financial review of the then bankrupt New York Railways Corporation graphically indicates the discrepancy between the costs of two rail track and three rail conduit track. In current prices, consider adding a zero after each cost shown. (Courtesy Stone and Webster 1917 evaluation of New York Railways Company.)

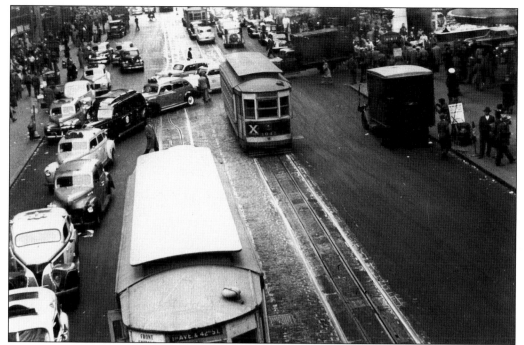

Although the New York and Harlem shared the track on 42nd Street between Madison and Park Avenues, they each had their own conduit rail supplying power only to their own cars, as shown in this photograph.

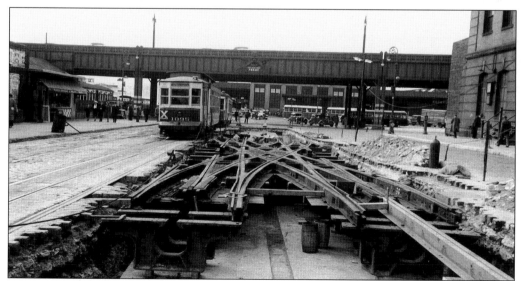

After the Green Lines abandoned their track at the West 42nd Street Ferry, the elaborate four-track terminal was simplified to two tracks for the Third Avenue Railway's use. Here the conduit "special work" is being prepared for placement in service in April 1939.

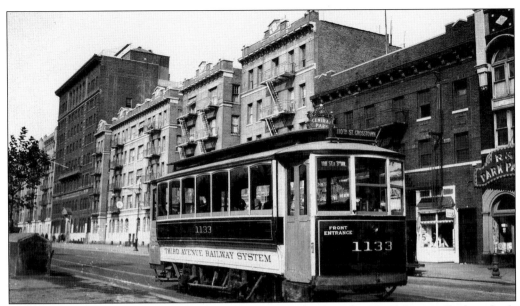

Unlike its competitor (New York Railways Corporation), when the Third Avenue Railway built their storage battery cars, they conformed to standard contemporary street railway designs. In later years, when revenues declined and costs soared, the Third Avenue was able to convert some cars to one-man operations such as this unit on the 110th Street crosstown line.

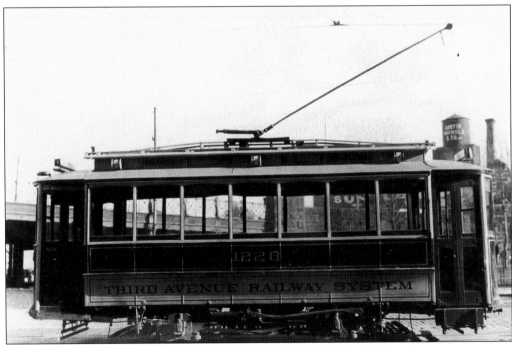

As their use of battery cars declined, the Third Avenue rebuilt some units to full electric operation for use on lightly traveled routes such as the Third Avenue Bridge shuttle service, as shown. Other electrified cars were sent to the Steinway Lines, which promptly rejected them.

Two

THE PLAYERS

By the early 1850s, the city had expanded far northward. Frederick Law Olmsted's Central Park concept had been accepted, and the area was in the process of being tailored to meet his imaginative plans. Manhattan's checkerboard grid street plans were in place. Fifth Avenue was already laid out and lined with fancy homes. The area below 42nd Street was now a paved road. The inference was obvious; the city was growing quickly, and the need for additional street transportation was urgently required. Although stage lines were operating horse-drawn omnibuses, they obviously were not the answer, especially since they ran on the yet unpaved city streets.

Since the concept of street railways was now accepted, new lines were being quickly franchised. Sensing that the New York and Harlem's lines were not sufficient to handle passenger traffic on the city's west side, in 1851, the city started the game by approving the franchises of the Sixth Avenue Railroad and the Eighth Avenue Railroad. The Sixth Avenue line was unique in that it consisted of two segments separated by the mass of Central Park.

Both the Sixth Avenue and the Eighth Avenue lines were awarded their routes without franchise fees, much to the consternation of the city's taxpayers, who had realized that money was being made without any benefits to the city. By the time the Third Avenue Railroad (later to become the Third Avenue Railway) received their franchise, the city was attempting to impose a franchise fee, but as one of the Third Avenue's grantees candidly related, he had personally "invested" money with local aldermen and received a bye when it came to franchise fees.

While the franchising situation was still in a fluid state, many new street railways asked for and received their franchises and started operation. The number increased so dramatically that two themes started to emerge. The first was that all too many of the companies were undercapitalized and were not generating sufficient revenue to remain viable entities. The second theme was that it was becoming obvious that a great financial opportunity was in the offing if any single, overriding company could consolidate these smaller lines into a single entity.

It was now obvious that the operation of horsecars had reached and probably passed the level of acceptability. The cost of keeping huge fleets of horses was not only impractical but remarkably expensive. Plus, of course, the residue left on the street by the thousands of horses was a major health hazard. So the street railway industry looked around and started experimenting on different ways to move the streetcars.

One method looked like a winner. The idea of moving cars by having them hook on to an ever moving cable was successfully working on the hills of San Francisco. So that technique was adapted for use on cities with a more friendly street profile. Cable railways were built in Chicago,

Brooklyn, St. Louis, Washington, D.C., Baltimore, and New York. The cable car lines worked fine but were dreadfully expensive to operate and maintain, and this factor was enough to have many transit companies turn away from this system.

And then one of those milepost incidents occurred that changed the direction of transportation history. During the winter of 1887–1888, the city of Richmond, Virginia, was testing the work of a young engineer, Frank J. Sprague, a former navy ensign. Sprague's work was one of many trying to develop a practical system for the electrical operation of street railway cars. Not only was his system spectacularly successful, but it became the prototype for virtually all subsequent electric streetcars in America.

Once it was determined that Sprague's system was workable, the installation of electricity on streetcar operations became a wildfire across the United States. Every system wanted to electrify—and they wanted to do it now. And the many individual companies in New York City were no exception. But, on Manhattan Island, there was an unexpected complication.

During the infamous blizzard of 1888, New York suffered an unexpected tragedy. In the city, telephone and electric lines were carried on a forest of line poles, some with as many as 40 cross arms. The snow and ice from the storm pulled down so many lines that, beside the blocking of street traffic, there was a major breakdown of both electric and phone services. The net result was that the city fathers passed a regulation that all utility lines had to be located underground. This also applied to the hoping-to-electrify street railways. A new technology was developed in New York to carry the electricity for the streetcars, but it was dreadfully expensive. The new technology was to power the streetcars via a slot between the running rails. Inside the slot were two rails carrying the electricity. Each streetcar would carry a "plow" that would contact the power rails, instead of the standard trolley wire overhead. The power rails inside the open topped "conduit" slot were held in place by cast-iron yokes. The cost of conduit power track configurations ran 3 to 10 times the cost of tracks built with overhead power transmission. This high cost brought the entire concept of electrifying the city's street railways to a screeching halt.

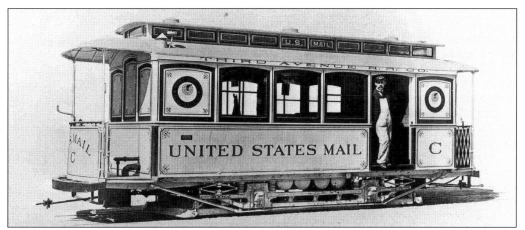

The Third Avenue Railway System originally purchased cars like this for cable car mail service. In this view, car C stands ready to move Uncle Sam's mail.

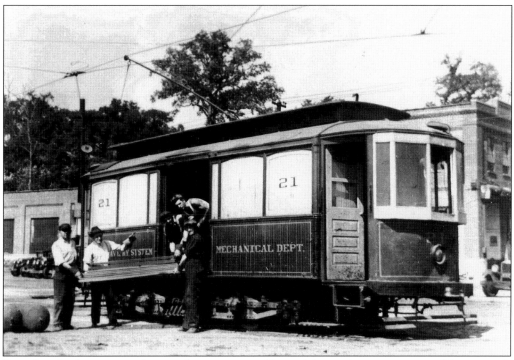

Four decades later, somewhat similar cars originally used for work service were still being used; the only difference now was that they were electrified and had their platforms enclosed.

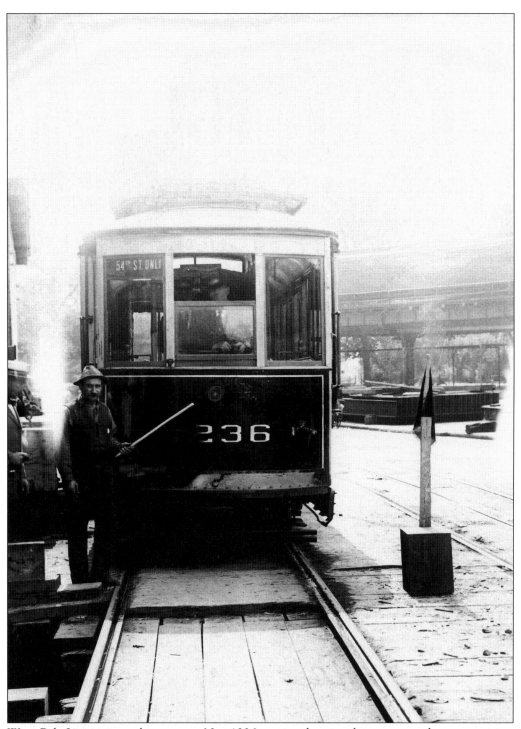

West Belt Line storage battery car No. 1236 awaits the signal to cross under-construction subway work at State Street in September 1915. These cars replaced the former Central Park, North and East River's horsecars when the Third Avenue Railway System took over the former company. (Courtesy Vincent Seyfried collection.)

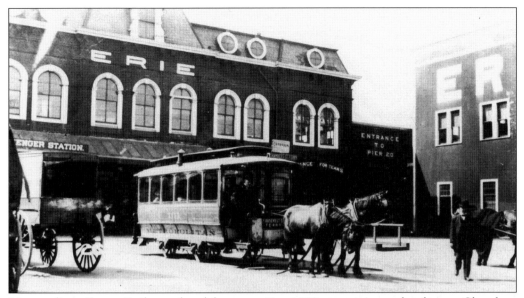

Metropolitan Street Railway closed horsecar No. 1133, running on the former Chambers Street and Grand Street Ferry Railroad line, awaits passengers at the Erie Railroad's Hudson River terminal.

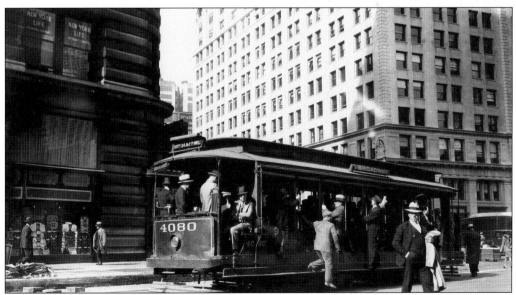

One thing to be said about open cars is that they certainly could carry a load of passengers. New York's first skyscraper, the Flatiron Building, forms the background (left) as businessmen disembark.

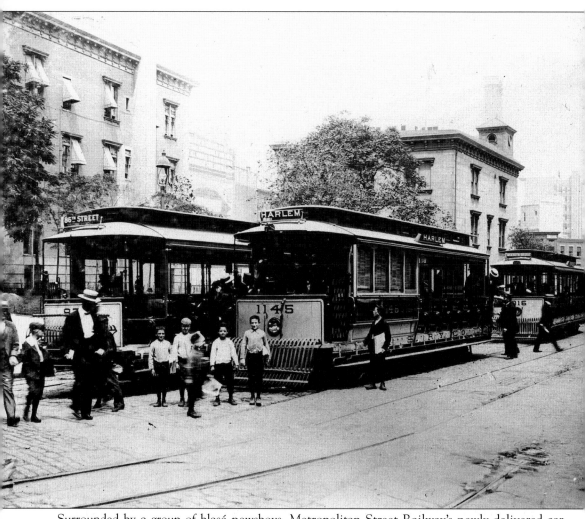

Surrounded by a group of blasé newsboys, Metropolitan Street Railway's newly delivered car No. 1146 was a sight to behold. It was a new type of electric rolling stock utilizing features of both open and closed sections. Many passengers still favored the fully open car on those balmy summer days.

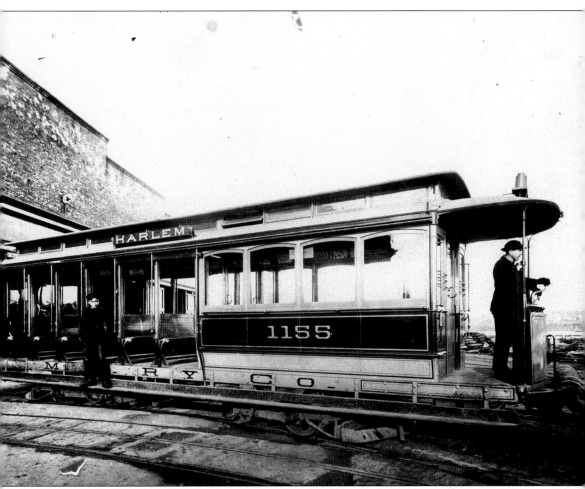

An experiment that did not work too well was the all-weather "combination" car (featuring both the popular open bench seats and a closed section), such as car No. 1155. Unfortunately, patrons used only the open section on warm days and the closed section on rainy or cold days. The fleet of 175 units was rebuilt in stages to fully enclosed cars.

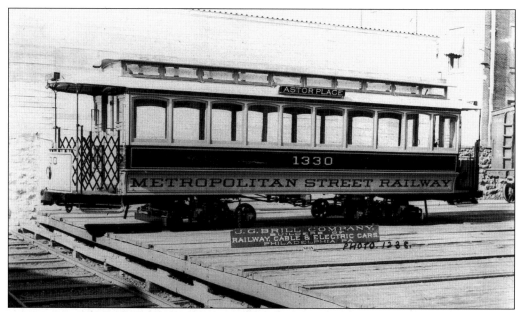

Representative of the Metropolitan's oldest rolling stock was car No. 1330, built in 1897. It was later "modernized" with closed platforms, platform windows, and mechanical doors and was used until the Green Lines terminated their final services in 1936.

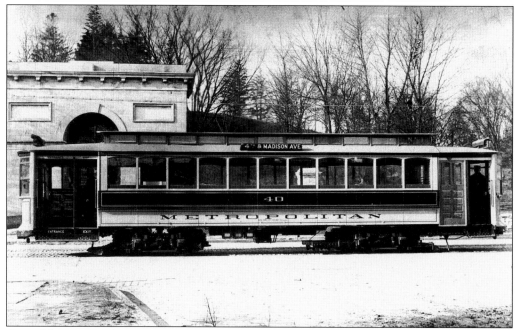

One of the Metropolitan's most successful car purchases was the 1-155 series, acquired from Brill in 1907. These huge cars with their large platforms were ultimately assigned to trunk routes of the New York Railways, the Eighth Avenue Railroad, and the New York and Harlem.

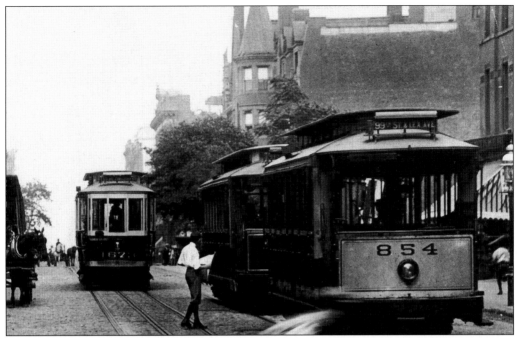

New York Railways' single truck open car No. 854 shares the rails with two closed cars on the Lexington Avenue route in 1913.

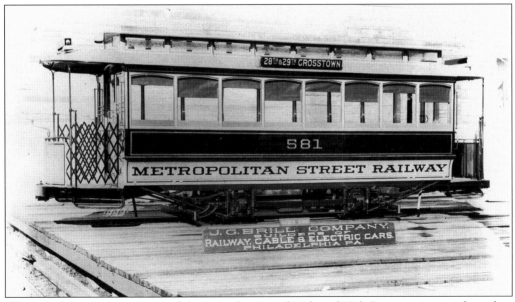

When the Metropolitan acquired the animal-powered 28th and 29th Streets crosstown line, they immediately starting tinkering with substitute prime movers. Car No. 581 was featured in an article in car builder J. G. Brill's house magazine as being an early compressed-air experimental car. It was not duplicated and early disappeared from the Metropolitan's roster.

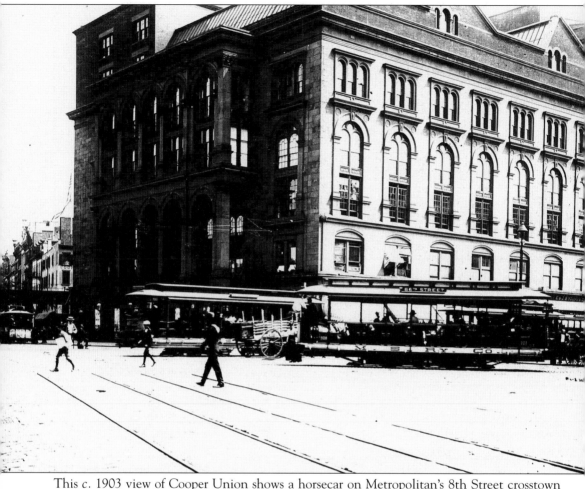

This *c.* 1903 view of Cooper Union shows a horsecar on Metropolitan's 8th Street crosstown line (extreme left), a double-truck open car (left), a double-truck closed car (background) on New York and Harlem's Madison and Fourth Avenue line, and single-truck open car (center) on the Metropolitan's Broadway line.

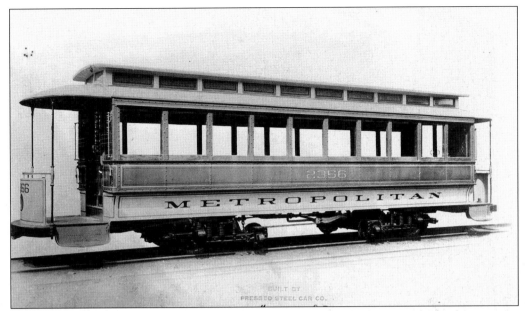

When formed in 1898, the Metropolitan Street Railway was desperately short of equipment and quickly purchased huge fleets of both closed and open cars. Once their original roster of equipment was sufficient to cover their daily operations, they started experimenting. In 1907, they authorized the Pressed Steel Car Company of Pittsburgh to design and deliver to them an all-metal version of their standard 10-window closed car. Car No. 2356 was the result.

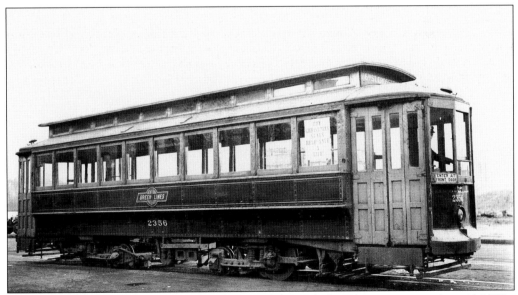

In Green Lines livery, No. 2356 soldiered on until the end of streetcar service in the mid-1900s, unchanged except for enclosed platforms and treadle doors.

In 1903, open car No. 4140 is ending its run down Broadway at historic Bowling Green Park on May 25, 1935. In a few months, both the car and the street railway will be gone forever.

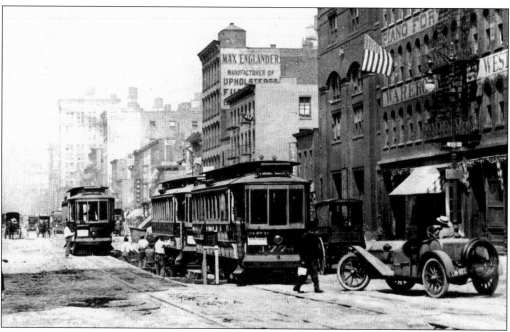

Shown are some standard closed cars with recently added front windows (vestibules). And, yes, that is a Stutz Bearcat pulling into traffic.

Three

MONOPOLY

In 1895, a new company was formed that would forever change the surface transportation picture in New York City. In that year, the Metropolitan Street Railway (third version!) was incorporated. Apparently having unlimited access to money, the Metropolitan's aspiration was to merge all of Manhattan's street railways into one consolidated system, and they succeeded. By the early 1900s, they had managed not only to get all of the small, independent companies folded into their family, but they also corralled the remaining "biggies" such as the Second Avenue Railroad, Eighth Avenue Railroad, the Ninth Avenue Railroad, the New York and Harlem (traction lines), and the Third Avenue Railroad together with their affiliated Union Railway (in the Bronx). One of their newly acquired companies was the New York City Interborough, a line serving the Bronx with five routes and with an on-street terminal at Broadway and 181st Street in Manhattan. But the New York City Interborough came with some baggage; it was owned by the Interborough Rapid Transit Company, operator of New York's first subway. So when the smoke had cleared, there was a new entity in town known as the Interborough-Metropolitan Company, which owned or controlled every single street railway company and rapid-transit line, including the Manhattan Railway's four elevated routes in Manhattan and the Bronx plus the Interborough Rapid Transit subway blossoming network.

One of the first things the Metropolitan did was to design and have built a fleet of standard streetcars to supplement and replace the collection of varied rolling stock inherited from their new acquisitions.

At the same time, the lines of the individual companies were rationalized into a cohesive network of routes integrated into a single operating system.

A program of electrifying the system was speeded up until all of the lines deigned to be viable electric routes were electrified. The nonelectric lines were still animal powered. And, finally, a comprehensive program of universal transfers was designed, so now passengers could transfer in many places between formerly competing lines.

Unfortunately, the financial structure of the Metropolitan had become something of a gigantic Ponzi scheme with new stock issued and sold among and within the component companies to try to maintain the Metropolitan's aim of annual dividends to the stockholders. The financial arrangements made in the melding of the individual companies into the single Metropolitan corporation necessitated the purchase of some of the component companies at exorbitant terms. This required the outflow of large annual sums of money and, together with the payout of

regular dividends, proved to be too much for the giant company to handle. By 1907, the huge consolidated company was in the hands of a receiver. Shortly thereafter, the major formerly independent companies started regaining their corporate identities and their assets. What was left after the crash was a much diminished traction company with a new name, the New York Railways Company.

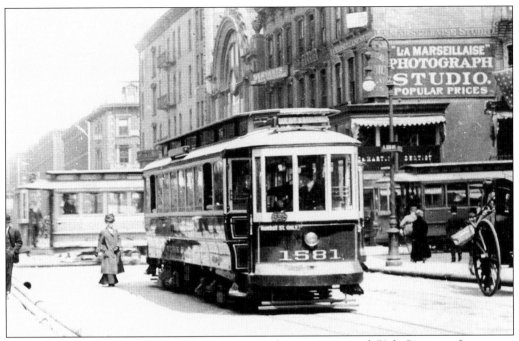

Open platform New York Railways car No. 1581 has just traversed 59th Street on Lexington Avenue. Crossing behind on 59th Street are two of the rarely photographed electric cars of the Central Park, North and East River Railroad.

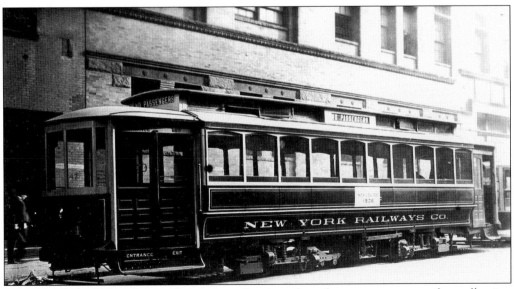

A newly refurbished and painted car was used to introduce the pay-as-you-enter fare collection concept in the 1912 Parade of Streetcars, which introduced newly designed modern cars on New York Railways.

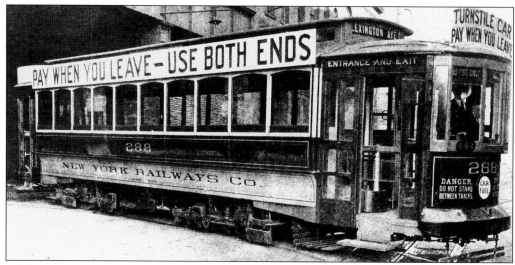

While in receivership, the New York Railways tried an experiment using a pay-as-you-leave configuration to quicken loading. Apparently not a success, it was not repeated, and the car was rebuilt to its former configuration.

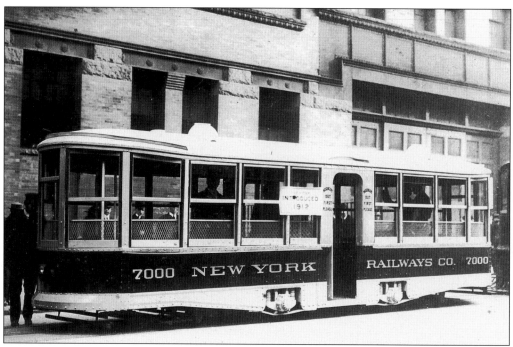

Car No. 7000 was the pilot model for the New York Railways' stepless storage battery car fleet. In 1912, it was in the Parade of Streetcars, wherein the new street railway showed off its fleet of state-of-the-art streetcars.

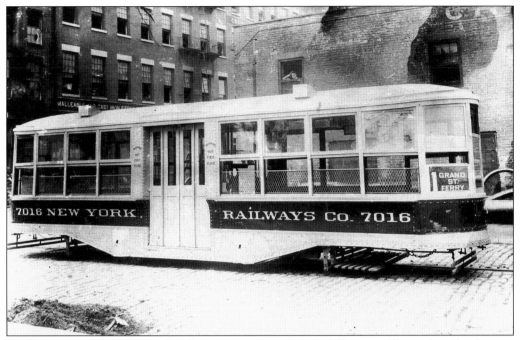

Production models of the stepless battery cars were slightly different, with much wider doors, a feature sorely deficient in the original design.

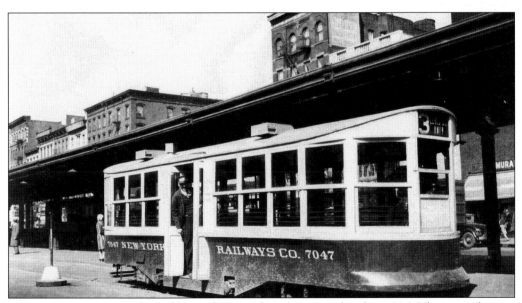

Car No. 7047 was one of 70 additional storage battery cars ordered in 1916. The entire battery car operation ended in 1919, although one service recommended on Delancey Street in 1921 for a short time. Why these additional cars were ordered is still a mystery.

The new center-door cars on the New York Railways' Broadway line featured a stepless entrance to allow ladies wearing the fashion-decreed hobble skirts to enter the cars with a minimum of showing their legs. The cars' operation was hampered by the too small doors and by the protruding lips at the car ends. Designed as a safety feature, the extensions invited unsuspecting motorists to strike them when cutting too closely behind the streetcar.

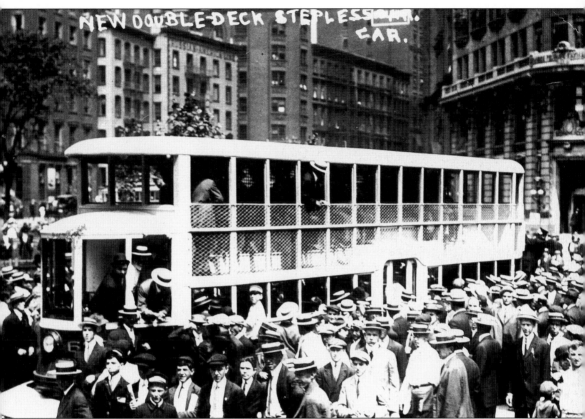

New York City's one and only double-deck streetcar, No. 6000 of the New York Railways, known as "the Broadway Battleship," was the center of attraction when it was introduced to the public in 1912 at lower Broadway's Bowling Green Park. The car was cleverly designed to fit under the numerous elevated railway structures along its route.

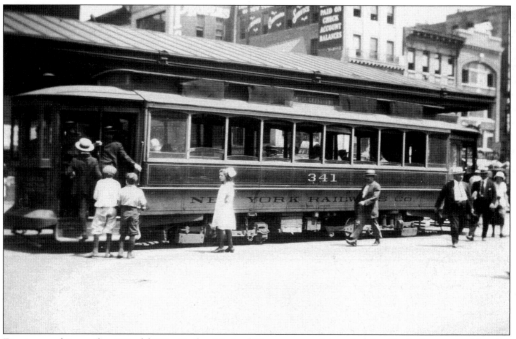

During and just after World War I, the United States experienced a deadly influenza epidemic. Some streetcars had their roof ventilators covered with black linen to ward off airborne germs.

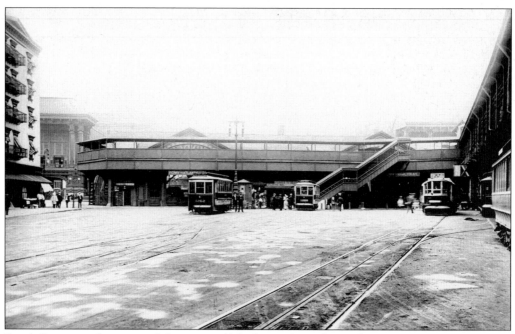

South Ferry was the terminal for many of Manhattan's north–south streetcar operations. From left to right are East Belt Line (Third Avenue Railway System) storage battery car No. 1262, West Belt Line car No. 1209, and New York Railways center door car No. 5067 assigned to the Broadway line, on June 28, 1914. (Courtesy Vincent Seyfried collection.)

New York Railways' Sixth Avenue Ferry line ran through an area of Manhattan in the process of being permanently changed by the building of the Interborough Rapid Transit Seventh Avenue subway line. A center-door storage battery trundles down Varick Street on a cold winter day in February 1914. (Courtesy Vincent Seyfried collection.)

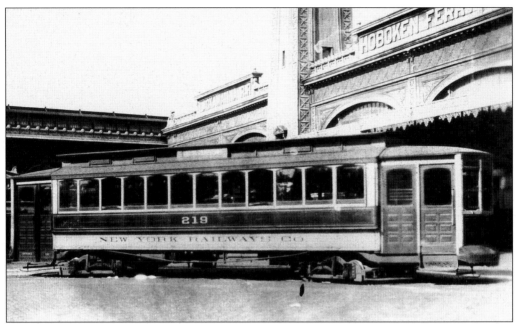

In 1924, the still bankrupt New York Railways Company sold off its fleet of long two-man conduit cars to Third Avenue Railways, which ultimately rebuilt them into one-man cars operated from trolley wire and subsequently used them for two decades.

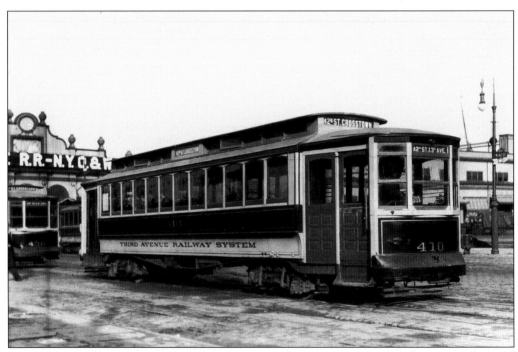

When the Third Avenue Railway received the cars, they repainted them to their new colors and immediately pressed them into conduit service. The cars were subsequently rebuilt for overhead wire and with treadle doors for one-man operation. Some units lasted until 1944.

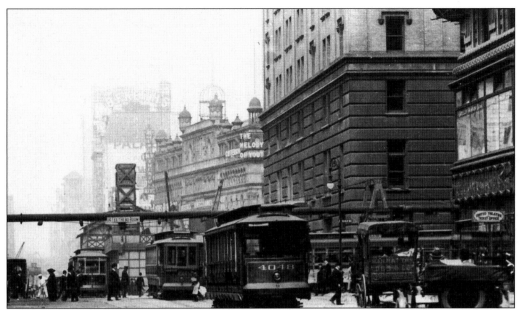

In this view looking north on Seventh Avenue toward Times Square, the streets are filled with streetcars. A Third Avenue Railway convertible waits to turn east toward its terminal at 42nd Street and First Avenue while New York Railways closed car No. 76 and open car No. 4048 wait their chance to rush north across 42nd Street. The Third Avenue Railway convertibles to the right are in 42nd Street crosstown service. The sooty building to the right is the New York Times building.

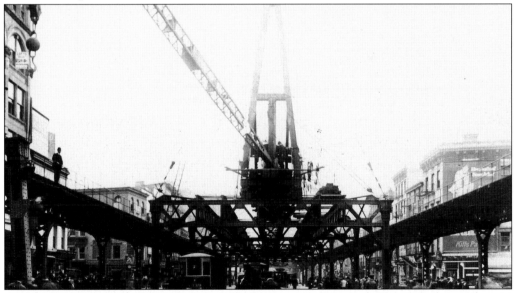

Around 1915, the City of New York embarked on a major program of expanding rapid transit. One of the projects was to rebuild the Manhattan Railway's elevated lines to offer express service on their Second Avenue, Third Avenue, Ninth Avenue, and upper Sixth Avenue routes. The traveling crane setting out steel for the Third Avenue line is shown along the Bowery in May 1915. The effect on the New York Railways and Third Avenue north–south routes were immediate—and devastating.

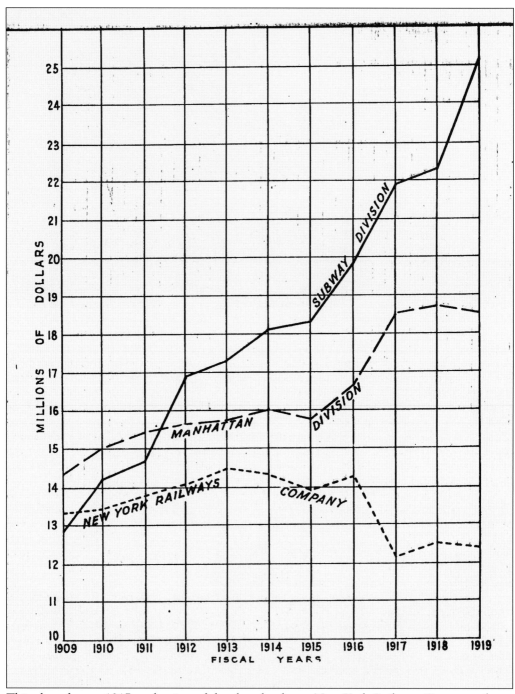

This chart from a 1917 evaluation of the then bankrupt New York Railways Company shows the effect of the 1916 opening of elevated express service and new north–south subway trunk lines on the New York Railways' revenue. The system would never recover. (Courtesy Stone and Webster 1917 evaluation of New York Railways Company.)

Four

THE BIG COMPANIES PART I

After the Metropolitan crashed, New York's surface transit system quickly realigned itself. It broke down into two major categories: the larger consolidated company (the New York Railways and the Third Avenue Railway System) and the smaller independent companies (the Eighth Avenue Railroad, the Ninth Avenue Railroad, the New York and Harlem, and the Second Avenue Railroad, and so on).

The New York Railways Company officially commenced on January 1, 1912. The new corporation was greatly influenced by the Interborough Rapid Transit system, which not only invested heavily in the new street railway company but also had people on the board of directors. During that time, the IRT also had investments in other traction companies in Queens and Long Island.

There had been a lot of soul searching in the time between Metropolitan's bankruptcy and the New York Railways formation with the result that many marginal and submarginal lines operated by "animal power," to use their own nomenclature, were completely abandoned and the rails removed. This was a prudent move since the wedge of lower Manhattan had been remarkably overbuilt with street railway lines that were obviously redundant. At the same time, many of the leased properties were cast loose, such as the New York and Harlem, the Eighth Avenue Railroad, and the Ninth Avenue Railroad.

At the time of rebirth, the new company had two categories of components. First were the wholly owned properties: the Metropolitan Street Railway (II), a fully operational company not to be confused with the Metropolitan Street Railway (III), the holding company; the Broadway Railway; the Chambers Street and Grand Street Ferry Railroad; the Columbus and Ninth Avenue Railroad; the Houston, West Street and Pavonia Ferry Railroad; the Metropolitan Cross Town Railway; the South Ferry Railroad; the Lexington Avenue and Pavonia Ferry Railroad; and the Central Crosstown Railroad Company of New York.

Second were the leased lines that were ultimately to cause so much difficulty with the financial situation of the new company: the Bleecker Street and Fulton Ferry Company; the Broadway and Seventh Avenue Railroad; the Christopher and 10th Street Railroad; the 42nd Street and Grand Street Ferry Railroad; the 23rd Street Railway; the Sixth Avenue Railroad; the Fort George and 11th Avenue Railroad; and the 34th Street Crosstown Railway.

Most of these companies owned major routes, but some were simply the short connecting

links between the major owned franchisees. Their financial lease arrangements meant that streetcars operating on those segments were obligated to share the nickel fare collected with those companies. Some of the New York Railways Company routes used the rails of up to five individual franchisees.

After casting adrift some of their better revenue-producing leased operations, the New York Railways Company took a cold hard look at what they had done and decided that, perhaps, they had acted prematurely. So, one by one, the New York and Harlem's heavy Fourth and Madison Avenue line and the long Ninth Avenue Railroad and its symbiotic relative Eighth Avenue Railroad were brought back into the family. It was to be a tumultuous relationship.

Once New York Railways Company management had worked out their operating scenarios, they looked at the newly hatched company from a marketing standpoint and came up with a remarkably bold plan. Encouraged by the car design people of the IRT, they proposed to launch a whole fleet of radically new cars based on the concept of easy access to their streetcars. The new equipment would have extremely low steps that would enable the passengers to enter and exit the cars quickly, thus theoretically moving the cars faster with the savings in labor and equipment accruing to the company's bottom line. Unfortunately, as modern and cutting edge as these cars were, they had a fatal design flaw. The doors were too small and aisles too narrow for passenger circulation within the car. Since all of the new cars had only center doors, all of the expected savings of the quick entrance and exit of the car design were nullified. Worse, this unexpected setback was not determined until a total of 293 cars were either irrevocably ordered or on site. In addition, as labor costs increased, the company realized that their center door design precluded the conversion of any of these cars to the more efficient and less expensive one-man operation. The ill-fated, drastic car design program was ultimately a major factor in the premature bankruptcy of the company, a kind of "let no good deed go unpunished" result.

During the days when the New York Railways Company was rationalizing its lines, it used four basic approaches: electrify and keep the line, abandon the line completely, replace horsecars with storage battery cars, and continue to run as animal powered. Oddly, one of their leased lines, the Bleecker Street and Fulton Ferry Company, had the distinction of operating New York's final horsecar line, terminating that service on July 26, 1917.

Four of the marginal lines were replaced by single-truck storage battery cars. Unfortunately, these were some of the aforementioned center door cars whose two-man crews made it difficult, if not impossible, to show a profit, and all four of those lines disappeared by September 21, 1919, after only three and a half years of battery car operation but not before the New York Railways Company inexplicably had placed an order for 70 additional battery cars. Where they were going to be used and why they were ordered is a mystery to this date. On February 1, 1920, a single line, Spring and Delancey, was restarted with a small fleet of battery cars. The line lasted until May 20, 1931.

New York Railways was completely unequipped to manage its rail empire, and in 1919 the company was forced into a bankruptcy that continued until 1925, when it reemerged as the New York Railways Corporation, the Green Lines, effectively owned now by a General Motors subsidiary, Omnibus Corporation, whose announced long-term plans included the motorization of their entire street railway system.

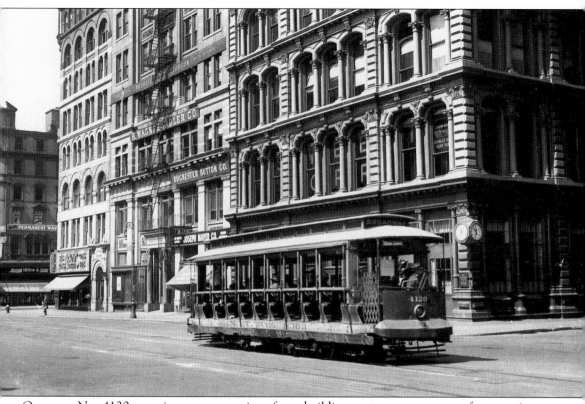

Open car No. 4120, running past a cast-iron-front building on a warm summer afternoon in 1935, is disturbed by neither riders nor traffic.

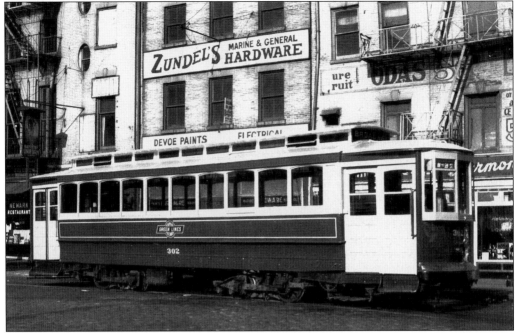

The wide vertical window post at the right end of this car identifies it as one of the rebuilt combination (half-open) cars. Only very sharp eyes would notice the difference.

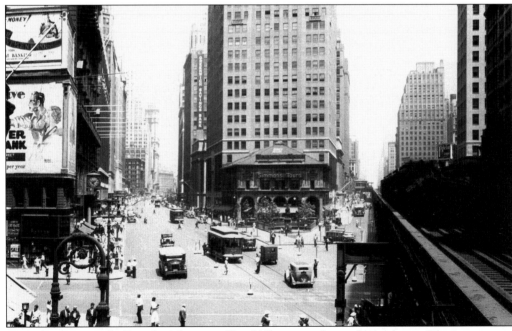

Open streetcars on the Broadway line pass Herald Square in this traditional view. The importance of the surface streetcars had been much diminished when the Brooklyn-Manhattan Transit opened its subway line, which virtually duplicated the street railway's route. The open cars ran until the end of street railway service on Broadway in 1935.

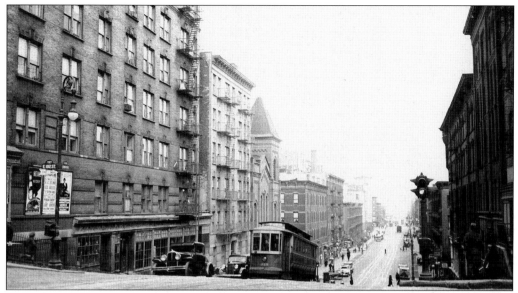

The terrain between 102nd and 103rd Streets on Lexington Avenue is very hilly. A Green Lines car is shown mastering the grade.

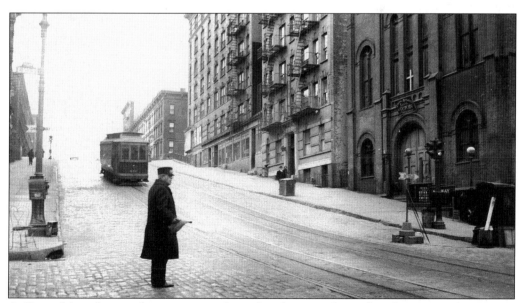

A Green Lines flagman has just given the right-of-way to descending Lexington Avenue car No. 492. Check out his spiffy "ice cream" chair under the mailbox (lower left).

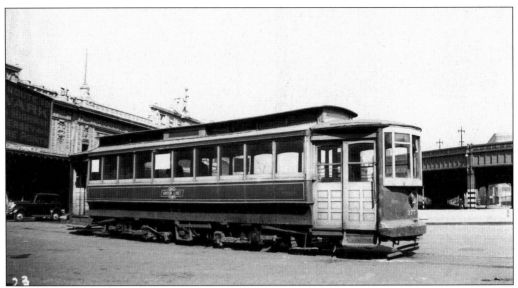

The 23rd Street Hudson River ferry terminal was a focal point for many streetcar lines. Rear entrance car No. 377 was assigned to the 23rd Street crosstown Green Line route.

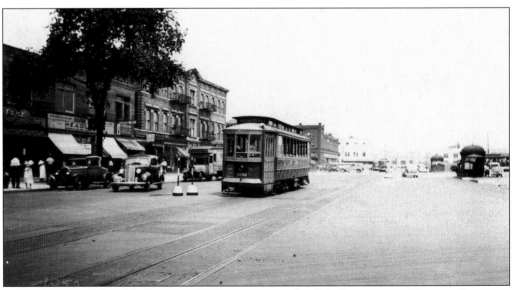

Lenox Avenue and 145th Street in 1935 was open and still had streetcars. This was the upper end of the Green Line's Lenox and Lexington Avenue route.

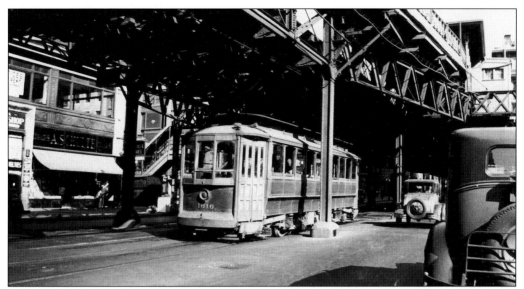

Dr. Rufus Gilbert's Metropolitan Elevated Railway ran over Sixth Avenue and Second Avenue. The station at Sixth Avenue and 42nd Street presented a shadowed cavern for Green Lines car No. 1616 heading north in 1933.

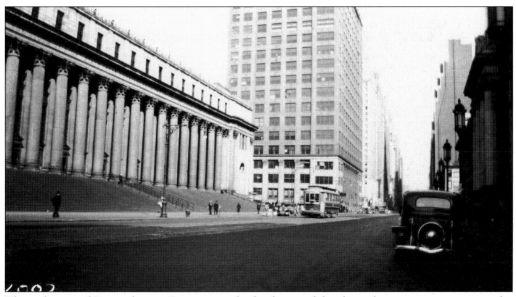

The columns of Pennsylvania Station are the background for this solitary streetcar serving the Eighth Avenue route in 1935.

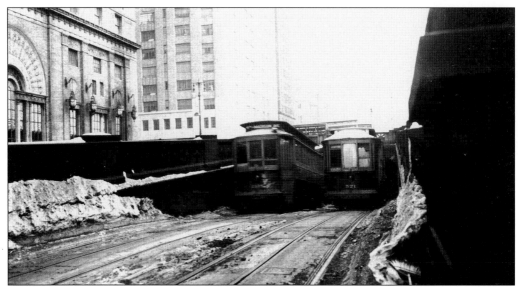

The south portal of the Murray Hill tunnel at 33rd Street and Fourth Avenue frames Green Lines car Nos. 2395 (left) and 521 (right). The tunnel was originally built in the mid-1850s by the New York and Harlem to move its steam cars by horses to its lower Manhattan terminals.

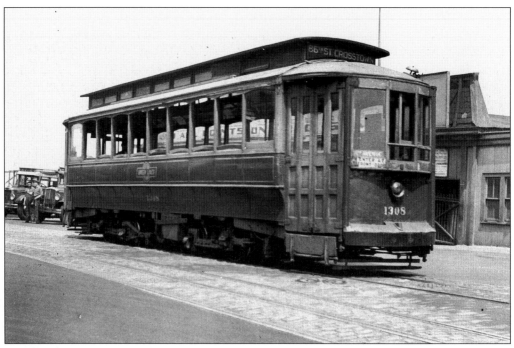

The 92nd Street and First Avenue ferry dock in the right background served Astoria, Queens, until Robert Moses "stole" the ferry apron, but that's another story. Note the nonfranchised buses behind the streetcar.

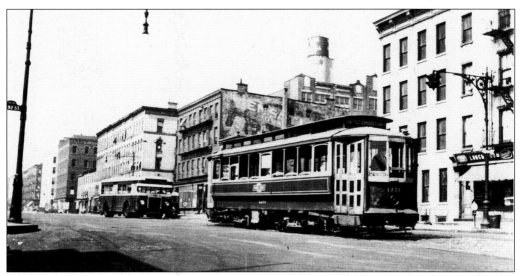

Green Lines car No. 1371 is at the end of its eastbound run at the ferry terminal at 92nd Street and First Avenue. The boxy bus of the East Side Omnibus Corporation, which succeeded the Second Avenue Railroad, streetcars run closely behind.

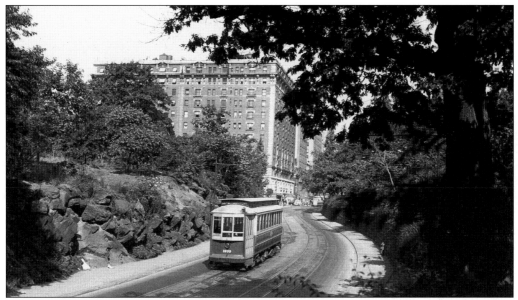

The former New York and Harlem's 86th Street crosstown line was unique in that it was the only streetcar line to traverse Central Park. Green Line car No. 1939 is heading eastbound from its verdant Central Park West terminal. The track within Central Park's boundaries was owned by the City of New York.

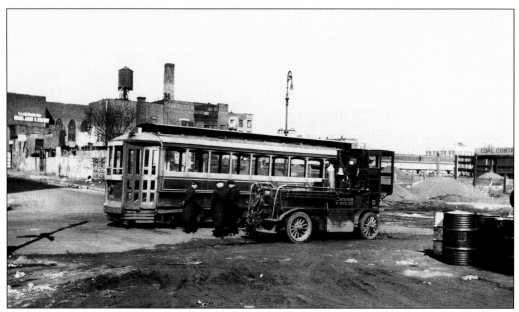

Although not strictly a streetcar, this motorized service vehicle sporting solid tires, chain drive, and battery power is certainly worth a photograph as an example of antique automotive technology.

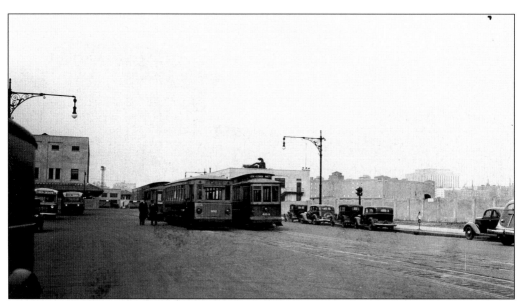

Green Line cars line up for rush-hour service at the 148th Street and Lenox Avenue terminal. Note car No. 4182 in line and the replacement buses already in use for the Fourth and Madison Avenue line. (Photograph by Sidney Silleck.)

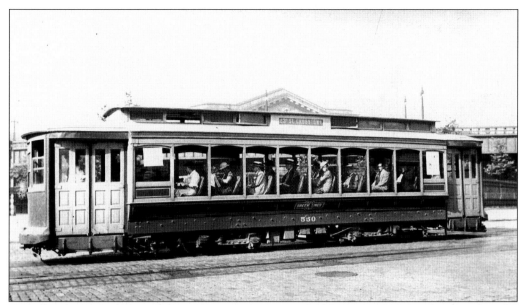

A modernization scheme of the Green Lines was to rebuild some cars in 1925 to emulate the Third Avenue Railway's popular convertible design of 1908. The car sides were removable. Car No. 550 demonstrates the design in open configuration.

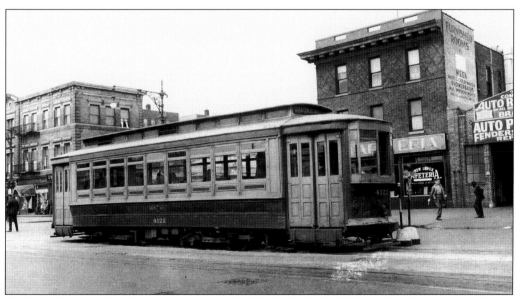

Green Line convertible car No. 4122, shown here in closed format, was built on the body of a former open car of the same number.

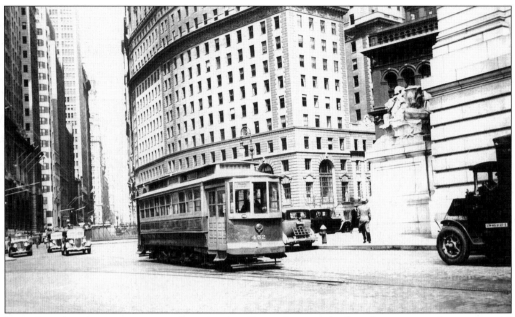

In a short-lived program to modernize, the Green Lines rebuilt a few cars, such as pictured No. 452, to cross seating, which was supposed to increase passenger comfort and, subsequently, riding. It did not.

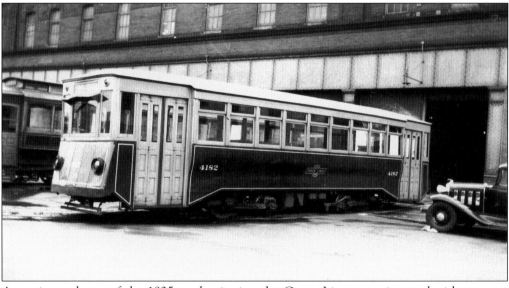

As an integral part of the 1925 modernization the Green Lines experimented with new car designs. They rebuilt one of their oldest open cars, No. 4182, into their idea of a "modern" streetcar. The experiment was not considered a success, but it permitted the company to proudly announce that they *did* have one modern car.

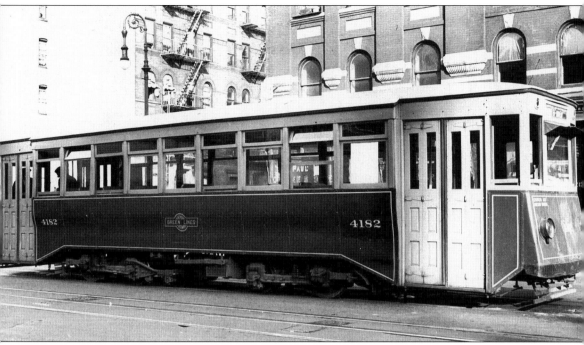

An almost full side view shows off car No. 4182's easily recognized features, such as sloped dashers with twin headlights, curved sides, arch roof, and low-level doors. Unfortunately the car's controls and motors were never updated, and the car was never deemed a success, nor was it ever duplicated.

A "ghost" car traverses Times Square. In order to continue their franchise after streetcar service was terminated on the Broadway line but before the new bus service started, the Green Lines ran this daily single car without passengers for three months in 1935.

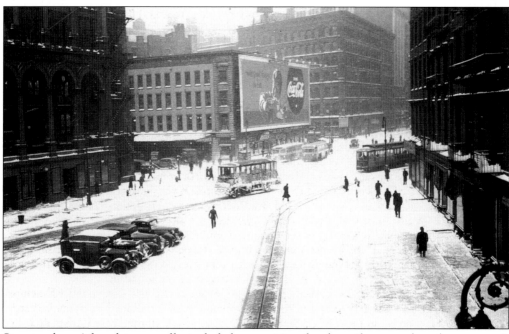

Street railways' franchises usually included a provision for the railway to plow the streets. A Green Lines sweeper has obviously done a better job than the municipal plows at Astor Place in this 1931 snow scene.

Five

THE BIG COMPANIES
PART II

Prior to the bankruptcy, for some reason New York Railways Company had an on-again, off-again relationship with some of its major leased companies. After its bankruptcy in 1919, the New York Railways Company once again released the New York and Harlem, which remained independent until December 17, 1932, when it was purchased by the succeeding Green Lines. The Eighth Avenue Railroad and its symbiotic twin, the Ninth Avenue Railroad, faced the same fate except that these two companies had financial problems of their own and merged to become the Eight and Ninth Avenues Railway Company only to be recaptured by the Green Lines on June 1, 1935.

The newly reformed streetcar system limped along with its antique fleet of streetcars, the newer center door fleet having been scrapped. A desultory program to rehabilitate some of their pre-1910 railcars was started in 1925. A small fleet of cars was refigured into an obsolescent 1908 convertible configuration, and a handful of cars had their seating arrangement changed. Finally, the company built its version of a modern car on the chassis of a former open streetcar. It was an abysmal failure. In 1926, because of recognition of their design shortcomings or because of lack of money or lack of incentive, the Green Lines terminated their car-modernization program forever.

By the early 1930s, major advances had occurred in motor bus design. Paramount among them was the invention of the pneumatically operated gearshift. This device enabled the bus driver to shift gears utilizing a semi-console mounted unit, thereby releasing him from looking at the vehicle's floor while shifting gears driving in traffic. The net result was that, for the first time, there was now a bus capable of handling the heavy traffic previously moved solely by streetcars. The stage was set for the first step of the end of the streetcar in Manhattan.

General Motors' Omnibus Corporation owned most of the Green Lines' street railway franchises, and they petitioned the city government to substitute buses for the railcars. The franchise battles started all over again when the motorization program commenced in the 1934–1935 period. The franchises of the streetcar company were ultimately passed on to three operating entities: the New York City Omnibus Corporation, which got the bulk of the system and its affiliates; the Eighth Avenue Coach Company, which picked up the former Eighth and Ninth Avenues Railway lines;

and finally the Madison Avenue Coach Company, which got the New York and Harlem's Madison and Fourth Avenue line. And, in 1936, the final streetcar line in New York, the 86th Street crosstown route, was motorized. Ironically it was the remaining segment of New York's and the nation's pioneer street railway company, the New York and Harlem.

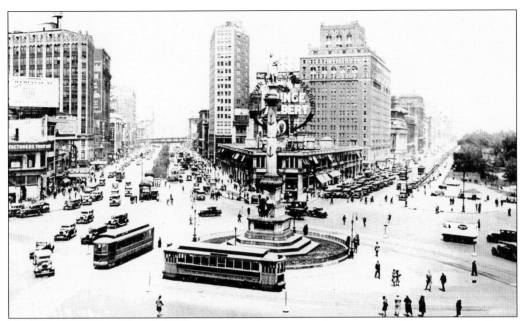

Manhattan's Columbus Circle was a center for street railway activity. The car in the lower center is the Third Avenue's 59th Street crosstown line, originally the Central Park, North and East River Railroad. The car to the left is running on the Eighth and Ninth Avenues Railway Eighth Avenue route. Central Park West and Eighth Avenue (upper right) is apparently a one-way street southbound with the streetcar tracks offset to the east side of the street.

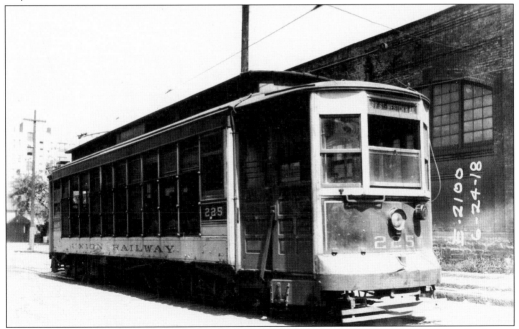

Although it was the practice of the Third Avenue Railway System to operate its subsidiaries under the corporate name, for a time the Union Railway system in the Bronx and lower Westchester County used the Third Avenue Railway livery, but their own name as shown on convertible No. 225 in repose between the two car houses at West Farms.

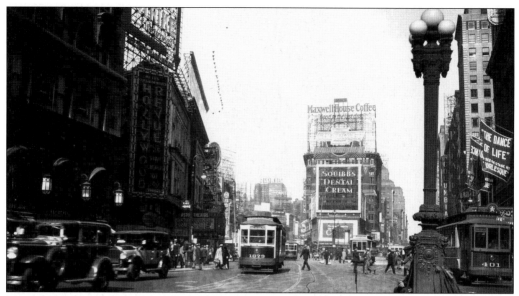

Until 1935, Times Square was served both the Third Avenue Railways (left) and the Green Lines (right). The brighter Third Avenue livery is highlighted when compared to that of the Green Lines equipment (far right).

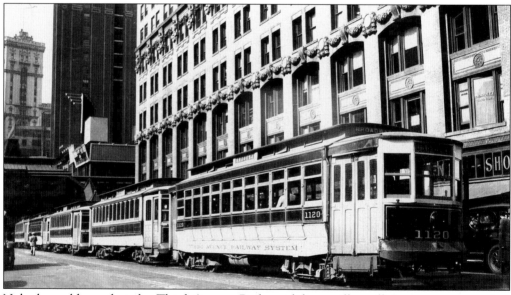

Nobody could say that the Third Avenue Railway did not offer sufficient streetcar service. A line of varied cars running on the 42nd Street crosstown line shared West 42nd Street with units operating on the Broadway line.

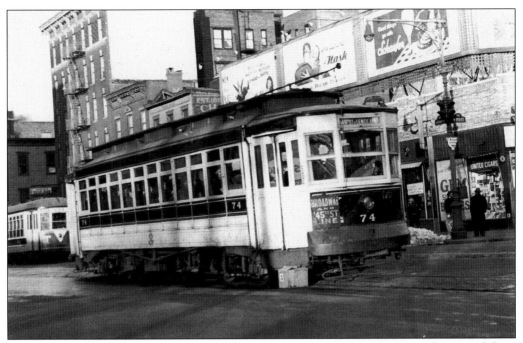

A few of the Third Avenue's upper Manhattan lines ran into the Bronx and operated from either conduit or overhead, such as this dual-service car on the Broadway and 145th Street line with the poles retracted.

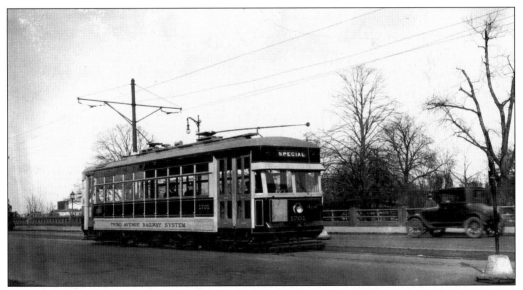

The Third Avenue was always willing to cooperate with car builders when it came to new and innovative equipment. Car No. 1701 was a compromise with J. G. Brill's designers, who were pushing their "Master Unit" design while the Third Avenue Railway System was still tinkering with the concept of a single-truck convertible. Interesting as it was, the design was not a success.

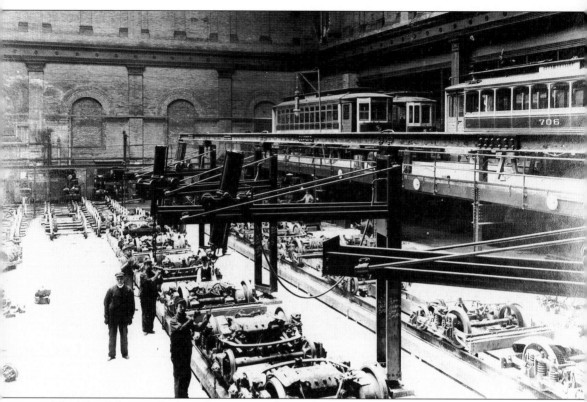

The Third Avenue Railway System was always short of money, and so they were very keen on maintaining, rebuilding, and even building its own cars. It was all done within the cavernous confines of the 65th Street and Third Avenue shops.

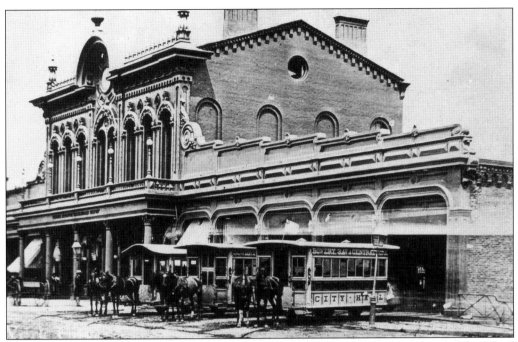

This marvelous example of pre-Victorian architecture was the main horsecar barn of the Third Avenue Railroad, at Third Avenue and 65th Street. Its construction even predated the building of the Third Avenue elevated line.

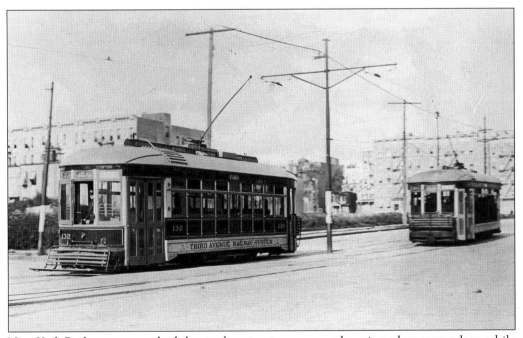

New York Railways approached the stepless streetcar concept by using a low center door, while the Third Avenue Railway System simply lowered the entire car body by using special trucks. The result was the Third Avenue's 101 series of single-truck convertibles, used on many light lines both in the Bronx and in Westchester County.

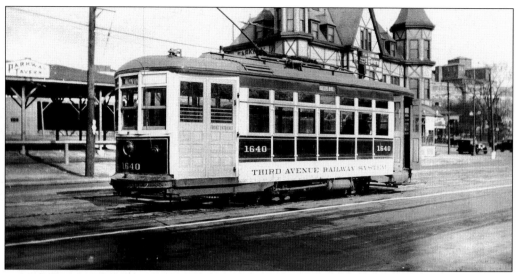

A second series of low-level convertibles was built in the mid-1920s, the cars being slightly higher and two panels shorter.

In the mid-1930s, when the Third Avenue Railway needed modern cars to replace their ancient rolling stock, they used the former 100 series and 1600 series cars as the basis for the new equipment. The old, single-truck convertibles were cut and a new section spliced in, creating a modern streetcar.

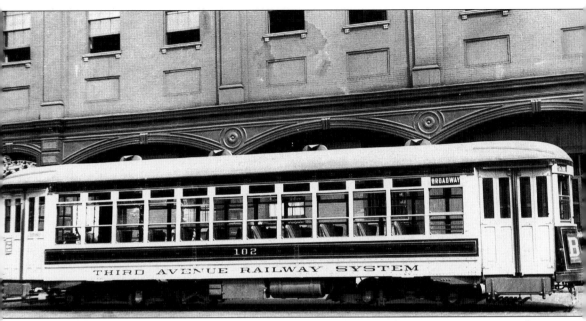

Here, in all its splendor, is the result of the 65th Street shop's excellent and imaginative work. The ever frugal Third Avenue Railway System also produced a version of the contemporary Brill 77-E truck by cutting and splicing sets of elderly former "maximum traction" wheel sets.

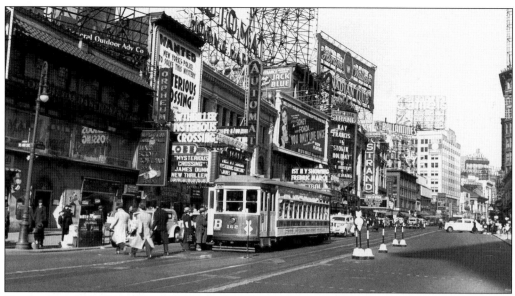

Newly minted rebuilt car No. 162 shows off on the upper reaches of Times Square in January 1937. These "rebuilds" matched many of the newer streetcars then operating in the United States.

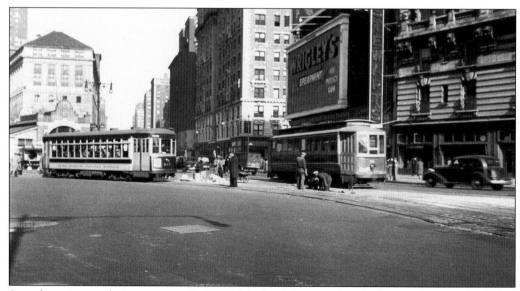

Seen here is a study in contrasts in 1935. To the left, a newly rebuilt streetcar on the Third Avenue Railway's Broadway line passes an ancient Green Lines car on its soon-to-be-abandoned Ninth and Amsterdam line.

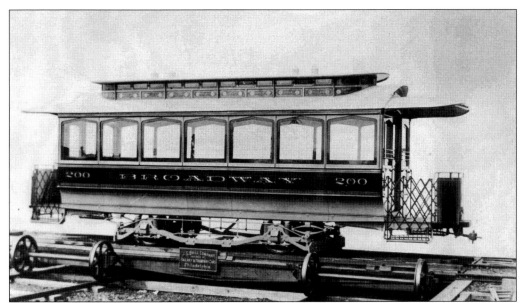

Built in 1893 by the J. G. Brill Car Company of Philadelphia as a cable car for the Metropolitan Street Railway, this car served as a model for 200 sisters built by Laclede Car Company of St. Louis. These cars were soon electrified, and when the Metropolitan Street Railway split up, a majority of the cars went to the Third Avenue Railway System, where they were used in passenger and, finally, work service until 1947. (Courtesy Krambles-Peterson Archive.)

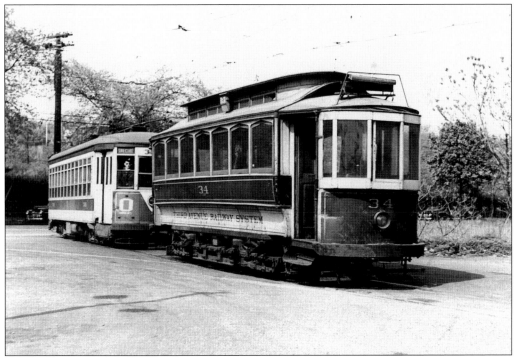

The Third Avenue Railway System's former cable car No. 34 has reached the end of the line. The year is 1947, and the ancient car is being delivered to the Garden Avenue yard for scrapping.

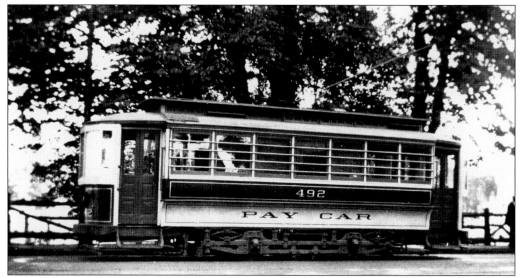

When the Third Avenue substituted newer cars for its upper Bronx and Westchester County properties, a large number of small, older cars was released for other services. Rebuilt car No. 492 collected revenue from various carbarns and delivered it to company headquarters at 128th Street and Third Avenue.

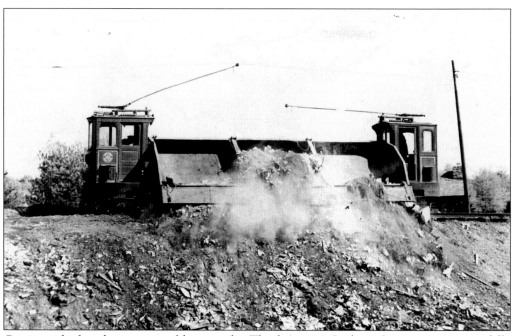

Getting rid of trash was no problem on the Third Avenue Railway System. It was carefully collected, loaded on cars (such as Differential Dump car No. 8, shown here), moved, and dumped in their pit in suburban Mount Vernon, where it served as fuel for burning scrapped cars.

Six

THE BIG COMPANIES PART III

Franchised on December 18, 1852, the Third Avenue Railroad was unusual in that, of all the "named" avenue street railway lines, it was the only original company to expand, rather than become a component of another system, such as the Sixth and Eighth Avenue Railroad and the Ninth Avenue Railroad, or like the Second Avenue Railroad, which never expanded much more than its original franchise.

In fact, the Third Avenue Railway System, early on, managed to lease or operate other streetcar lines or systems. Even during those piratical days when operated by the Metropolitan Street Railway, the Third Avenue and its family companies were listed separately in the Metropolitan Street Railway's annual financial reports. And when the Metropolitan system failed and was dismembered, it was the Third Avenue that got first shot at the disbursement of street railway equipment from the Metropolitan's polyglot pool of traction cars.

However, when the Third Avenue received its independence in 1907, its financial situation was in such tatters that it promptly declared bankruptcy and reinvented itself as the Third Avenue Railway Company, and its once again reunited components thereafter bore the operating title of Third Avenue Railway System.

The Third Avenue Railway System's family of lines operating in Manhattan ultimately consisted of the Third Avenue Railway Company; the Kingsbridge Railway; the 42nd Street, Manhattanville and St. Nicholas Avenue Railway; the Dry Dock, East Broadway and Battery Railroad; the 28th and 29th Streets Crosstown Railway; the Belt Line Railway (formerly the Central Park, North and East River Railroad); the Third Avenue Bridge Company; and the partially owned Brooklyn and North River Railroad.

In addition, the Third Avenue Railway System owned or operated some lines in southern Westchester County and virtually all of the Bronx trolley routes, some of which continued on to Manhattan.

The company was always known for its tight operation and its financial wizardry, but even they could make some mistakes when it came to adding new companies to their roster. Their purchase of the 28th and 29th Streets Crosstown Railway with its operation down those narrow, minor crosstown streets of Manhattan was probably their biggest gaff. On the other hand, in its later days when the company realized that its fleet of surface cars was almost entirely obsolescent,

they became most proficient in a new area, the art of purchasing used equipment. The first step in their modernization program was to scour the secondhand streetcar market for cars that would fit into their operational scheme. When that program proved successful, they used the type of car they purchased as a model and modified a fleet of tiny, single-truck convertible cars into an armada of large, modern double-truck cars that were comparable to virtually any contemporary car running in the United States. In fact, the car-building program was so successful that they were still in the process of constructing new cars on the day that New York City's government forced them to embrace a motorization program if they wished to keep their franchises.

Unlike the somewhat bedraggled and dowdy New York Railways, the Third Avenue Railway System always kept their cars in sparkling clean and neat condition, and until the company was in its death throes, a car that needed paint or minor repairs was never seen on the street.

The Third Avenue Railway System owned or operated a number of subsidiary companies in Manhattan. The key property was their namesake Third Avenue Railway. Their lower East Side operation was the Dry Dock, East Broadway and Battery Railroad, which had one conduit line, Grand Street, and a number of former horsecar lines that were converted to battery operation and early abandoned. However, their Avenue B line was New York's last storage battery line, soldiering on until July 30, 1932. Their major Manhattan component was the 42nd Street, Manhattanville and St. Nicholas Avenue Railway, which among other lines, operated their highly profitable Broadway Branch line and the heavy 42nd Street crosstown line. Their other important operations included the former Central Park, North and East River Railroad, later known as the Belt Line, whose lines encapsulated New York's central business area. Former horsecar lines, later battery operated, started at 59th Street and ran along the East River and Hudson River waterfronts, meeting at South Ferry. The highly utilized 59th Street crosstown electric line ran from the East River ferries via 59th Street and Bloomingdale's very popular department store and then across the southern border of Central Park to West 54th Street and 10th Avenue.

In contrast to the New York Railways, the Third Avenue Railway System's management had tremendous insight when it came to their operating philosophies. The New York Railways Company doggedly held on to a system operating almost entirely in an aging city area, while the Third Avenue Railway System quickly realized that their lower Manhattan lines, their peripheral lines, and their marginal storage battery lines were doomed to a long, lingering death because of changing business and traffic conditions in their market area. So they unceremoniously abandoned the unprofitable Dry Dock lines and affiliated themselves with the Union Railway, the major operator of trolleys in the Bronx and lower Westchester County. The Union Railway's market area was blessed by the extension of the IRT and later independent subway lines, which effectively dispersed the hordes of people living in the teeming East Side Manhattan areas to new vistas in the Bronx. So the Union and Third Avenue Railway System built new lines or strengthened current lines to access these newly developing neighborhoods—and placed themselves in the mid-20th century. Sadly, the image of the streetcar in New York was officially declared *persona non grata* by the city government, and in spite of clear-sighted efforts to keep the streetcar as its main means of transport, the Third Avenue Railway System was fighting an unbeatable foe who, by the early 1950s, would vanquish their concepts through legislation.

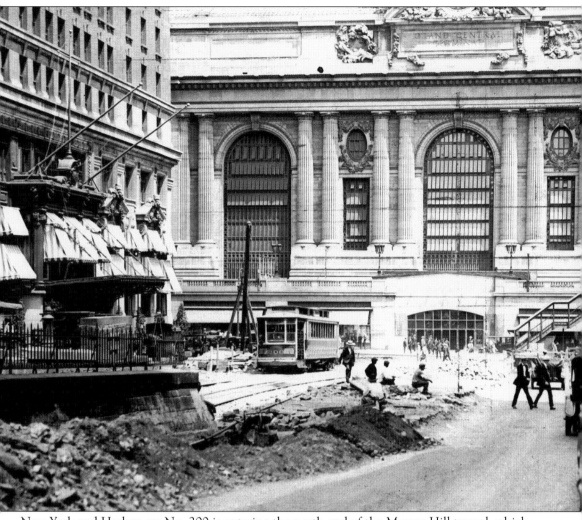

New York and Harlem car No. 200 is entering the north end of the Murray Hill tunnel, which will carry the car nonstop to 33rd Street and Fourth Avenue. Note the steps of the Third Avenue elevated shuttle line to Grand Central Terminal (background) in 1918. (Courtesy Vincent Seyfried collection.)

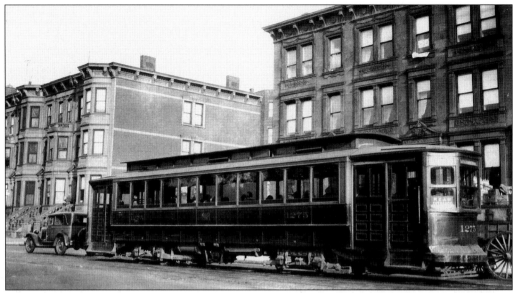

The New York and Harlem Railroad operated two street railway routes. Long car No. 1275 covered the heavy Fourth and Madison Avenue trunk line, while a very rare photograph (below) shows car No. 1105, which ran on the 86th Street crosstown line. The Fourth and Madison was the first line in the Green Lines family to be motorized under the bus substitution program, and the 86th Street line was the last Green Line route to go.

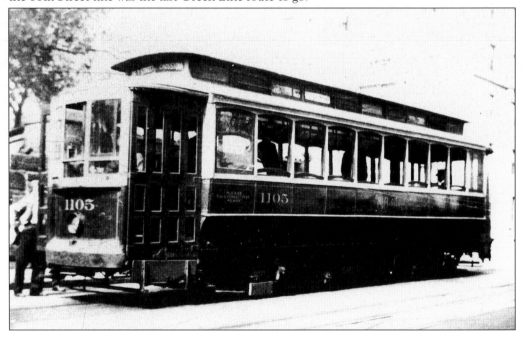

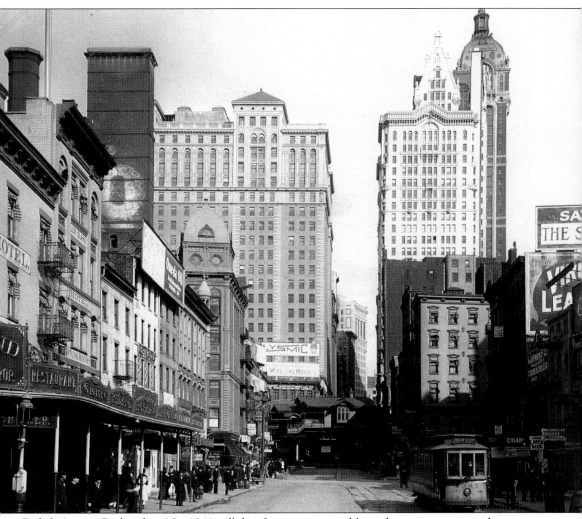

Eighth Avenue Railroad car No. 1341 will shortly retrace its northbound route up its namesake street from the southern terminal at the Cortlandt Street ferry terminal around 1919. The domed Singer (sewing machine) building glowers in the background. (Courtesy Ken Spengler collection.)

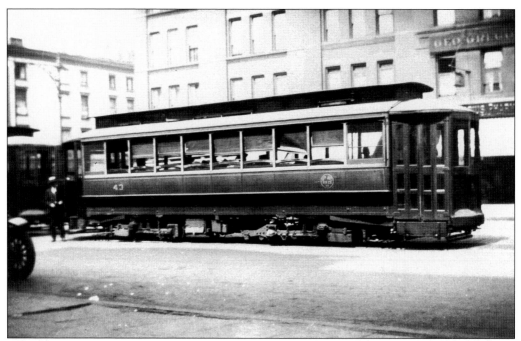

When the New York Railways went into bankruptcy in 1919, they spun off two client street railways—the Eighth Avenue Railroad and the Ninth Avenue Railroad. At that time, they also released fleets of standard 10-window cars to each company. Rarely photographed cousins, Eighth Avenue No. 43 (above) and Ninth Avenue No. 252 (below), are shown here.

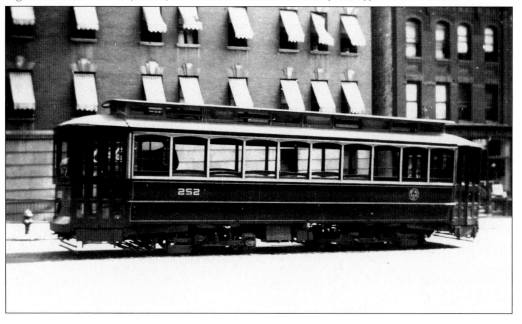

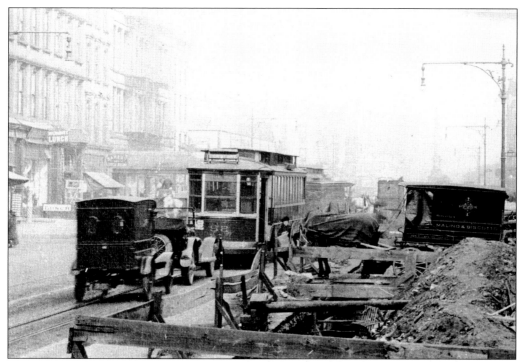

This is a unique view of one of the few long cars (series 1-155) assigned to the Eighth Avenue Railroad in service on Eighth Avenue and 52nd Street.

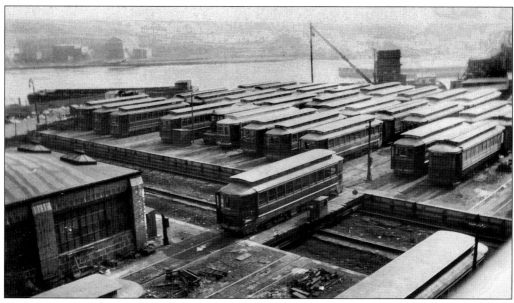

Carbarns and yards were always a source on wonderment and discovery. The Eighth and Ninth Avenues Railway's 155th Street yard was no exception. Besides a collection of ancient but still used streetcars, note the "transfer table" that enabled the yard crew to move cars easily between tracks without benefit of switches.

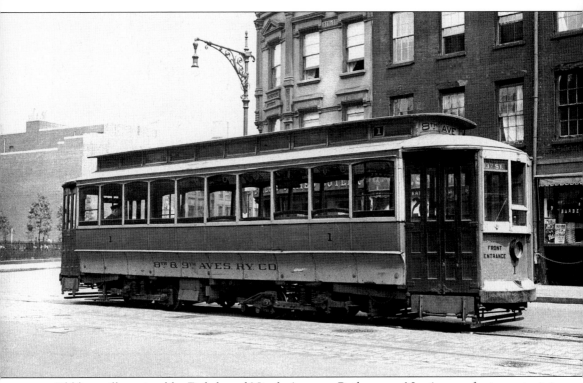

Old but still serviceable, Eighth and Ninth Avenues Railway car No. 1 poses for its portrait in May 1935.

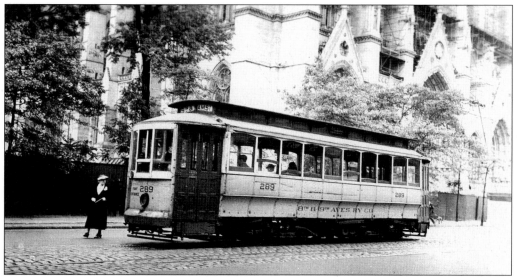

With the ramparts of the Cathedral of St. John the Divine in the background, Eighth and Ninth Avenues Railway car No. 289 growls its way up Amsterdam Avenue. Its number gives away the fact that the car was formerly the property of the Ninth Avenue Railroad.

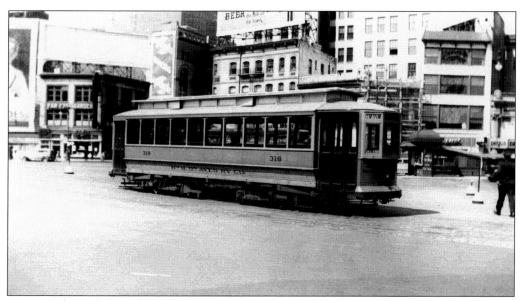

In 1934, the Eighth and Ninth Avenues Railway was short of equipment, so they purchased 17 somewhat derelict cars from the New York City Department of Plant and Structures, which had used these already secondhand cars on its Williamsburgh Bridge line and on the former Staten Island Midland operations. In this view, car No. 318 clatters across Columbus Circle.

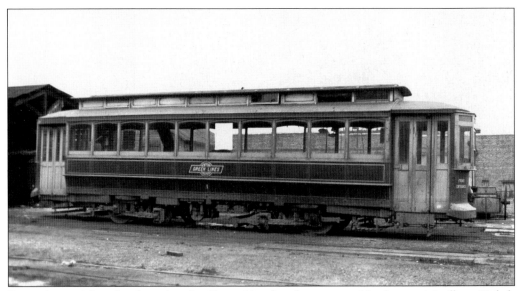

Recently renumbered and repainted to Green Lines' apple green, car No. 1 was originally an Eighth and Ninth Avenues Railway car. Six months after the cosmetic redo, the line was abandoned.

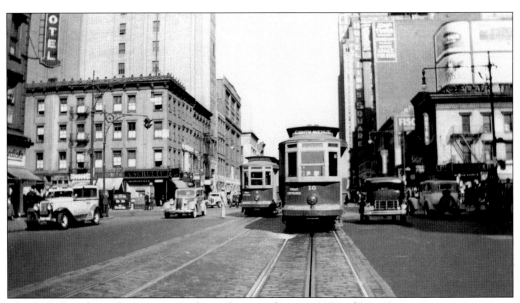

The Eighth and Ninth Avenues Railway's last purchase in 1934 of "new" equipment was a series of 17 secondhand cars built in 1902. A brace of these cars in Green Lines livery is shown on Eighth Avenue months before the line was motorized. (Courtesy Al Seibel.)

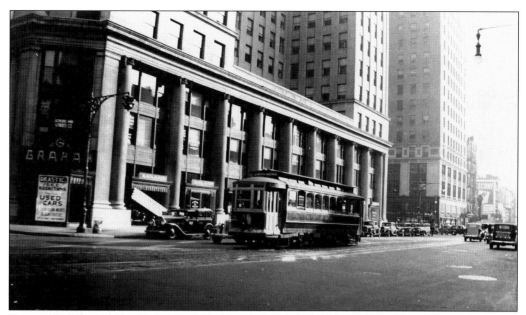

Former Eighth and Ninth Avenues Railway car No. 311 (now in Green Line disguise as their No. 5) has midtown Eighth Avenue all to itself in the spring of 1935.

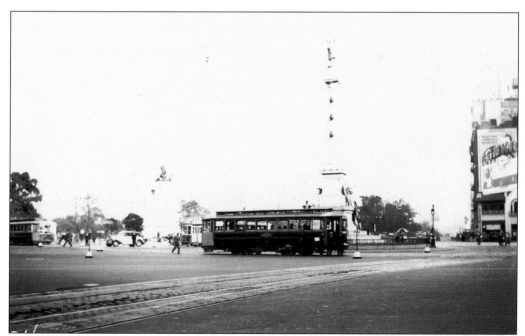

Cars of the Eighth and Ninth Avenues Railway in Green Line livery traverse Columbus Circle in 1935, the last year of streetcar operation. Note the modern Third Avenue Railway car behind the foreground surface car. (Courtesy Al Gilcher.)

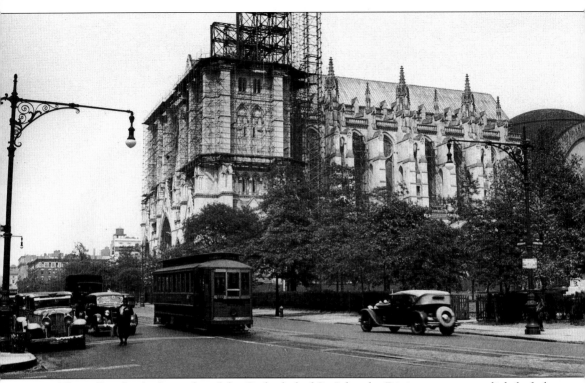

The still unfinished steeples of the Cathedral of St. John the Divine tower over slightly forlorn car No. 261 as it heads south on Amsterdam Avenue. The people in that sporty touring car on the right are missing the passing of the streetcar in more ways than one. (Courtesy Fred W. Schneider III collection; photograph by Francis J. Goldsmith Jr.)

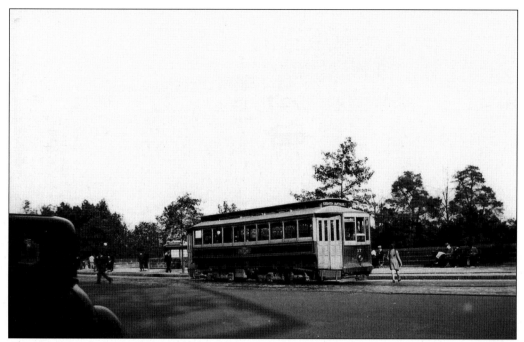

Car No. 17 of the Eighth and Ninth Avenues Railway's Eighth Avenue line is running south at Central Park West and 85th Street. Note that the tracks are offset, running along the east curb.

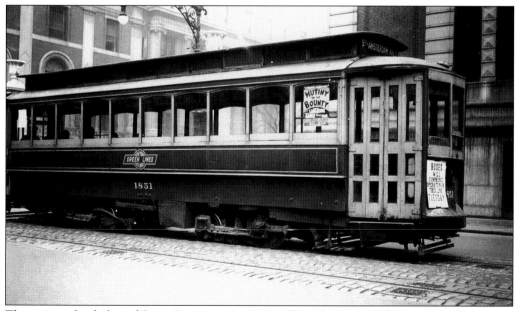

The sign on the dasher of Green Lines car No. 1851 tells it all: "Buses Will Commence Operation on This Line Tuesday." (Courtesy Kevin Farrell collection.)

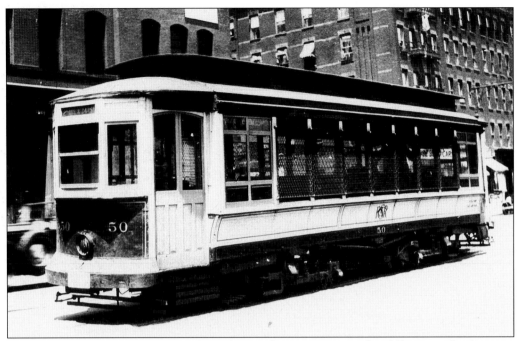

When the Metropolitan Street Railway dispersed its equipment after falling into bankruptcy, former component company Second Avenue Railroad inherited a fleet of open bench cars, most of which they quickly rebuilt into convertible cars like car No. 50.

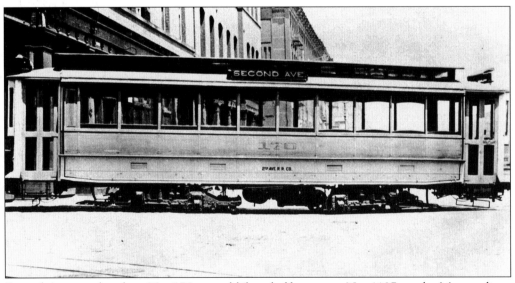

Second Avenue closed car No. 170 started life as half-open car No. 1197 on the Metropolitan Street Railway and was converted by the new owners shortly after it was delivered.

Seven

THE SOMEWHAT INDEPENDENT LINES

Interspersed between the major companies (that is, the New York Railways and the Third Avenue Railway System) was a group of street railways that were intermittently independent and later became components of the larger systems.

The first and most complex was the New York and Harlem Railroad, whose main line, the Fourth and Madison Avenue route, was the most heavily used street railway in New York. They also operated a crosstown route, the 86th Street line, which ran from 86th Street and Eighth Avenue (Central Park West) east through Central Park's Transverse Road to York Avenue and 86th Street, where it turned north, terminating at the 92nd Street ferry slip. This was the New York Railways Corporation's last streetcar line, and ironically it was still owned by New York's first streetcar company, the New York and Harlem Railroad.

The next of the independent companies was actually a duo of semi-related street railways: the Eighth Avenue Railroad and the Ninth Avenue Railroad. The two lines had paralleling north–south routes from upper Manhattan to lower cross-Hudson ferry terminals. Both lines were, at times, operated by the Metropolitan Street Railway and later by both the New York Railways Company and its successor New York Railways Corporation, the Green Lines. After twin bankruptcies, the two reorganized as a single company, the Eighth and Ninth Avenues Railway. In 1935, as the Green Lines was cleaning up its corporate structure, it purchased the reconstructed company and, apparently for bookkeeping purposes, started repainting its equipment in New York Railways Green Line livery and numbering system. This was the last "improvement" made on rolling stock by the Green Lines. Later that year, all of the former Eighth and Ninth Avenues Railway routes were motorized under the Eighth Avenue Coach Company name.

The last independent company was the Second Avenue Railroad. Originally independent, it became part of the giant Metropolitan Street Railway. When that company disintegrated, it once again became independent. For some reason, during the dispersal of the Metropolitan's rolling stock fleet, the Second Avenue seemingly got the "bottom of the barrel." The oldest and most worn out cars were passed on to them. It took them many years to rebuild their ragtag fleet of streetcars into marginally acceptable equipment. The Second Avenue's route structure ran from a lower Manhattan terminal on Worth Street to Second Avenue. At that point, the

line went north, overshadowed by the Second Avenue elevated line, which covered its entire Second Avenue route to its upper end at 129th Street. At 59th Street, a spur line went east to First Avenue and then turned north to its terminal at 125th Street. The company was the weakest of all of the north–south lines and was the first to be replaced by buses. The East Side Omnibus system took over their rail lines in 1933. Considered a poor relation during its entire history as a street railway, the property had the last laugh. After the East Side Omnibus was swept into the MABSTOA family and its lines rationalized under Manhattan's one-way street program, the resulting bus route, M-15 covering First and Second Avenues, became the most prosperous of Manhattan's bus lines. There is some kind of poetic justice in that outcome.

As New York City slowly grew northward, it was obvious that, as an island, it had some shortcomings. One was that people with business to transact in New York City had a major problem getting across the defining rivers. The answer was ferry boats connecting the city with other communities across the water. There were two distinct categories of passengers. The first group included those who lived east of Manhattan's island. Since the East River was quite wide and very fast flowing, it was obviously beyond the technical skills of the mid-1800s to build a connecting bridge. Therefore, many private ferry companies were established along the east bank of the East River. The earliest was Robert Fulton's New York and Brooklyn Steam Ferry Boat Company, which initiated services between those cities in 1814. It later became an integral part of New York's major ferry operator, the Union Ferry Company. The Union Ferry Company, once known as the wealthiest and most important ferry company in the world, would later operate many routes across the East River, terminating in Manhattan at six different ferry slips. Most of these ferry terminals at both sides of the river were also terminals of local horsecar street railway lines, and many were considered to be great sources of consistent revenues for about half a century.

Another major Brooklyn-based ferry operation was the Williamsburg Ferry Company, which under various corporate names, ran three routes terminating at two Manhattan slips. Other lines went from Greenpoint Avenue landing, from Grand Street (Brooklyn) and from 39th Street (Brooklyn), to Whitehall Street, to various Manhattan terminals.

The Long Island Rail Road ran ferry services connecting with their trains at Hunter's Point, in Long Island City from Manhattan slips at both James Street and East 34th Street.

Virtually all of these East River marine services were met by street railway lines at their slips at both ends.

Another set of ferry lines was operated by the railroads that terminated in New Jersey but commercially required their passengers to alight in Manhattan, across the Hudson (North) River. These included lines of the New York Central Railroad; the Pennsylvania Railroad; the Delaware, Lackawanna and Western Railroad; the Jersey Central Railroad; and the Erie Railroad. Their trans-Hudson lines terminated at 11 different Manhattan slips, representing a very long lasting and comprehensive spectrum of services. All of these ferry lines were met in Manhattan by local streetcar lines and were considered to be major sources of revenue by the street railways. They were affected by the opening of the Holland Tunnel, the Lincoln Tunnel, and the George Washington Bridge, but some Manhattan streetcar lines soldiered on until after World War II.

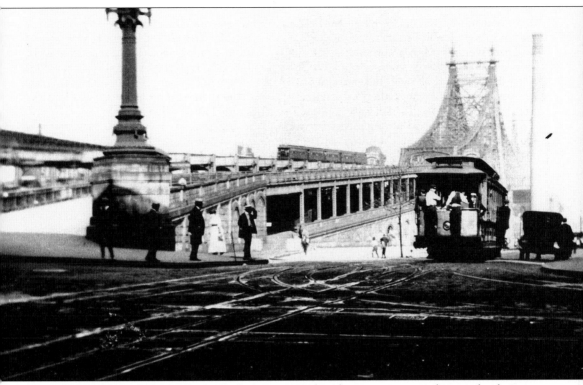

This photograph has it all. A Second Avenue Railroad open car, complete with clinging passengers and a conductor on the running board collecting fares, rolls east toward First Avenue, where it will continue its voyage until it reaches the Harlem River at about 128th Street. Meanwhile, a Second Avenue elevated train is en route from Flushing on the upper level tracks of the Queensborough Bridge.

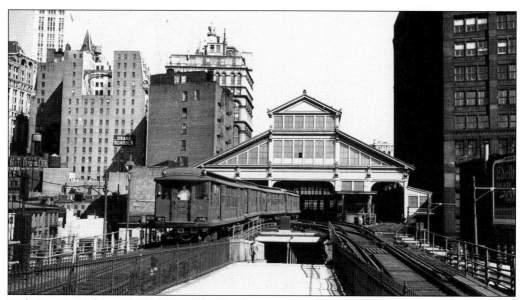

Park Row was the western terminal of both the Brooklyn streetcars and the elevated rapid-transit lines. Note the trolley line poles at the extreme right of the photograph. New York's city hall is just behind and to the left of the huge station complex.

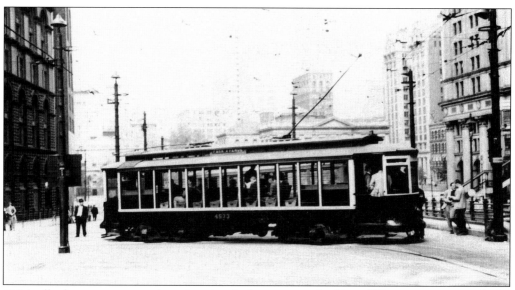

Originally the streetcars terminated under the large station building. When it was removed, the cars turned on this tight curve.

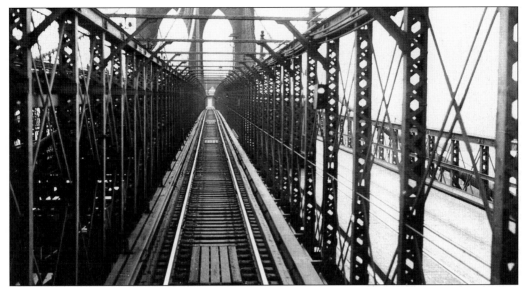

Originally, cable-powered rapid-transit trains used this track to cross the Brooklyn Bridge. Later, the cable was replaced with the third rail, as shown here. Note the streetcar track just to the right in the automobile lane. When the rapid-transit lines were abandoned, the track was again rebuilt to overhead wire and used by streetcars of the former Brooklyn and Queens Transit.

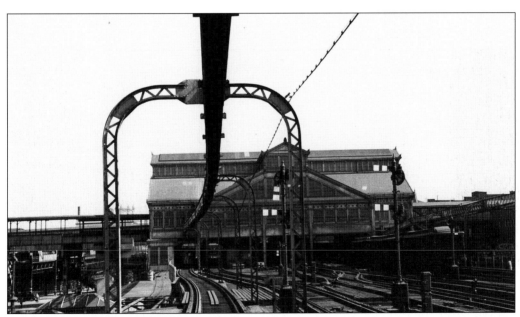

Sister to Manhattan's Park Row terminal was Brooklyn's Sand Street edifice, originally the eastern end of the cable-powered transriver rapid-transit line. The lacey overhead structure carried the power for the latter-day trolleys.

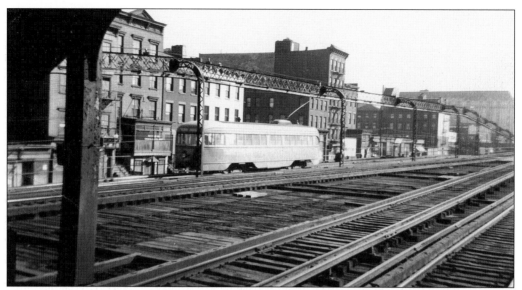

The Brooklyn Bridge was a beehive of transportation activity. In order to ensure that the streetcar's trolley poles did not lose power at the Brooklyn end, power was transmitted by wire held up by overhead gantries, a second cousin to the technique used in Grand Central Terminal's electrification. A Brooklyn and Queens Transit PCC car shows how it worked.

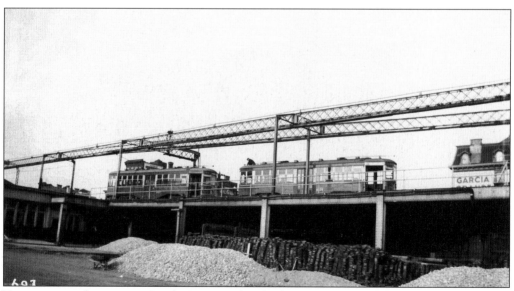

Two streetcars lay over at Sands Street under the heavy structure that carried the overhead trolley wire.

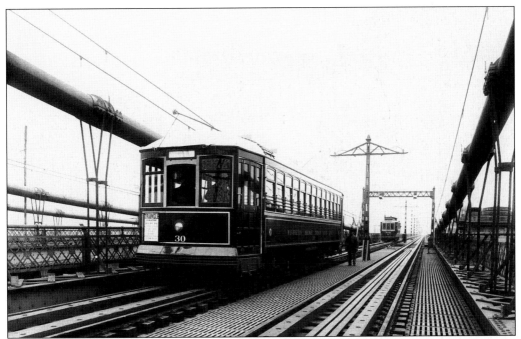

On opening day of the new right-of-way, Manhattan Bridge Three Cent Line car No. 30 precedes single-truck No. 302 on the upper deck of the Manhattan Bridge.

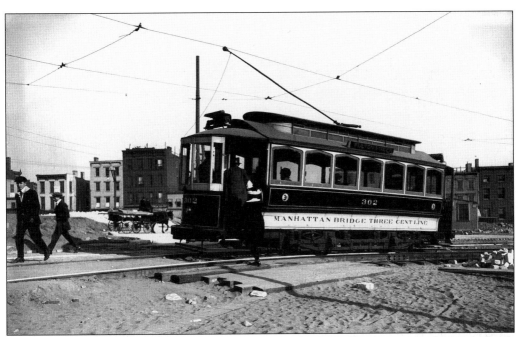

The Manhattan Bridge Three Cent Line inaugurated transbridge services with these rebuilt former cable cars purchased indirectly from their competitor, the Third Avenue Railway. This car is exiting the Brooklyn end of the recently completed bridge en route from Manhattan.

The Brooklyn terminal was at Flatbush Avenue Extension and Fulton Street. The in-street terminal was shared with cars of the competing Brooklyn and North River.

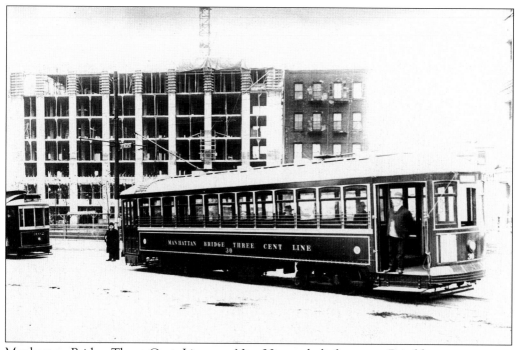

Manhattan Bridge Three Cent Line car No. 30 stands before new Brooklyn construction obviously the result of the completion of the Manhattan Bridge. Note single-truck car No. 302 lurking in the left background.

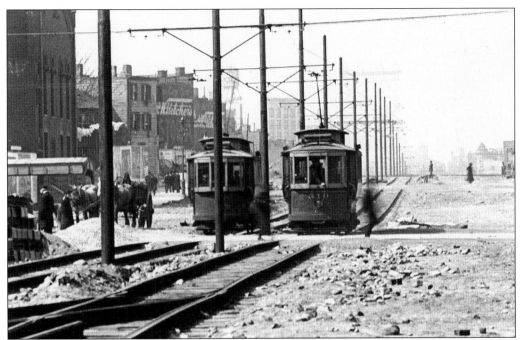

Two 300 series cars of the Three Cent Line pass on a still unpaved Flatbush Avenue Extension. The Manhattan Bridge's tower is vaguely discernable in the distance.

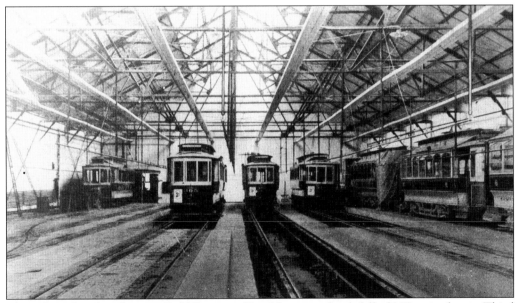

Three Cent Line's carbarn at Gold Street, in Brooklyn, was chock full of 300 series former Third Avenue cable cars. Note the inspection pit track in the center foreground.

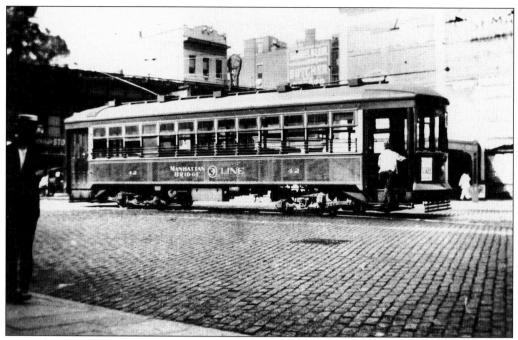

Second-generation equipment on the Three Cent Line, such as car No. 42, ended up on the Queensboro Bridge Railway two decades after this portrait at the Brooklyn terminal.

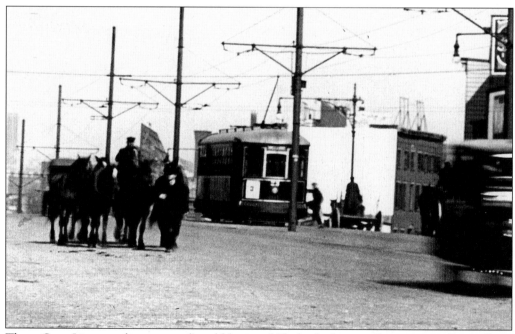

Three Cent Line car shares a newly cobblestoned Flatbush Avenue Extension with a walking team of horses.

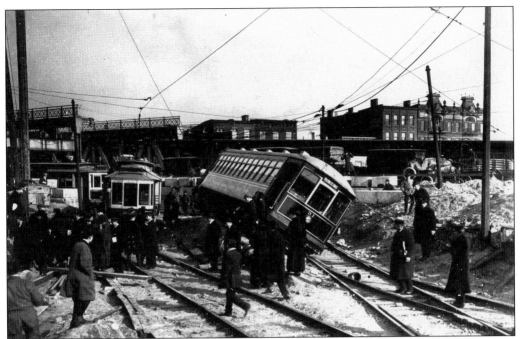

Recently delivered Manhattan Bridge Three Cent Line car No. 31 lost a fight with older equipment at the Manhattan terminal in 1914.

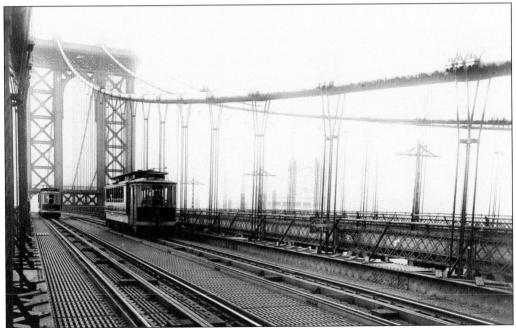

The Brooklyn and North River line was the other streetcar line operating on the Manhattan Bridge. It utilized the cars of the Third Avenue Railway System, appropriately lettered. Car Nos. 731 and 736 pass near the middle of the bridge. Note the conduit rail set between the running rails. The competing Three Cent Line's catenary towers are visible in the background of this April 1917 photograph.

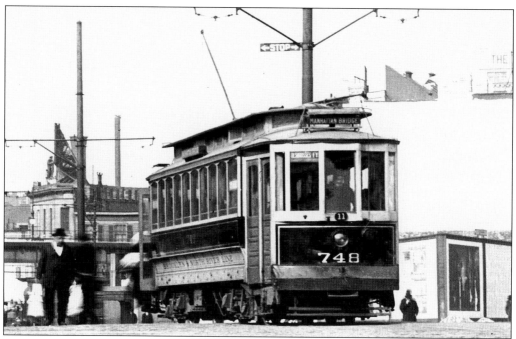

Brooklyn and North River's car No.748 has just left the Manhattan Bridge (stonework in left background) and will use trolley wire for the rest of its journey to the Fulton Street terminal.

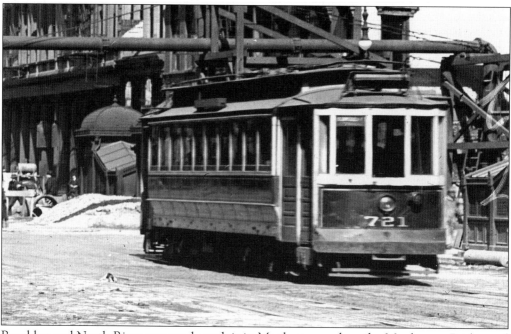

Brooklyn and North River cars used conduit in Manhattan and on the Manhattan Bridge and trolley wire when operating in Brooklyn. Brooklyn and North River car No. 721 traverses Canal Street on its way to the bridge.

Eight

THE EAST RIVER CROSSINGS

By the time the Brooklyn Bridge, the first solid connection between Brooklyn and New York City, was opened in 1883, there were at least 12 ferry routes in operation between Manhattan and Brooklyn, using 10 different ferry terminals in Brooklyn and 11 in Manhattan. Each terminal in both cities was a major destination point for multitudinous street railway lines. The effect of opening the Brooklyn Bridge was devastating to the East River ferry companies. By 1898, the streetcar companies in Brooklyn no longer transferred their loads to the waiting ferries but continued across the bridge, terminating their runs a single block away from New York's city hall.

The ferry companies quickly started discontinuing transriver services and closed their waterside terminals. Since the Brooklyn trolleys were now operating over the bridge, this had minimal effect on them and on the many streetcar lines now serving Manhattan directly. There was a wholesale readjustment of the Manhattan-based street railway lines, with many routes being diverted to other terminals in Manhattan side while others were declared redundant and were abandoned in their entirety.

With rapid-transit trains now starting to feed the Brooklyn Bridge entrée to Manhattan, even some of the Brooklyn trolley lines started readjusting. However, in the long run, the trolleys of the Brooklyn Rapid Transit, later the Brooklyn and Queens Transit, continued to carry heavy loads across the bridge, complementing the crowded rapid-transit elevated lines that terminated at a huge terminal at Manhattan's Park Row.

Geographically, the next bridge across the East River was the Manhattan Bridge, soon to become the scene of one of the most self-defeating traction sagas in New York's history. In 1909, the Manhattan Bridge was completed, and a new, independent trolley company was eager to run the transbridge streetcar service. The Manhattan Bridge Three Cent Line was incorporated on December 30, 1909, to operate a streetcar line from the Brooklyn terminal of the Long Island Rail Road at Flatbush and Fourth Avenues to the Hudson River ferry terminal in Manhattan at Desbrosses Street, crossing Manhattan mostly via Canal Street. On July 10, 1912, after many hearings and delays, their franchise was finally issued. When it became clear that they would obtain their franchise, the "big traction companies" (New York Railways, Third Avenue Railway and the Brooklyn Rapid Transit) combined to form the Brooklyn and North River Railroad, designed primarily to compete directly with the upstart Three Cent Line, with roughly the same

route and terminals. For some reason, both companies neglected to notice that the bridge was also to carry tracks for major Brooklyn Rapid Transit subway lines, then under construction.

The two streetcar companies battled for months over their duplicate routes, with the Brooklyn and North River Railroad effectively winning by having a ruling that cut back the Three Cent Line's western terminal to an off-street loop at the Manhattan end of the bridge while they received the rights to cross Manhattan to the disputed Desbrosses Street terminal. The Three Cent Line was to use overhead wire on their entire route, while the Brooklyn and North River used conduit construction on their Manhattan street running section, on the bridge and part of the way to a joint end-of-track now located at Flatbush Avenue and Fulton Street in Brooklyn.

To tweak the corporate nose of their competitors, the Three Cent Line quickly opened their electric service using secondhand equipment previously sold by the Third Avenue Railway to a used streetcar dealer who passed them on to the Three Cent Line. These cars had originally been built to run on the Third Avenue's cable car lines. Within a short time, they were replaced by a fleet of large, modern trolley cars. The Brooklyn and North River, being a combination of three companies, delegated the Third Avenue Railway to supply their equipment. The Third Avenue Railway System assigned a fleet of their 700 through 850 series cars to this service.

Once the Brooklyn Rapid Transit subway line finally started crossing the bridge, it was obvious that there simply was not enough business for one street railway, let alone two. By 1919, the Brooklyn and North River gave up the ghost, and on November 13, 1929, the Three Cent Line gladly surrendered their trolley franchise to New York City, ending a short, unhappy story of street railway operation on that bridge.

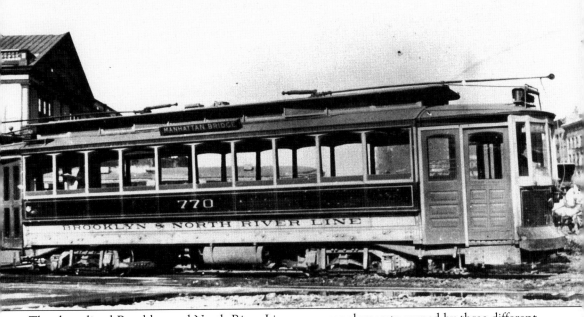

The short-lived Brooklyn and North River Line was a conglomerate owned by three different companies but was operated by (and with equipment from) the Third Avenue Railway System.

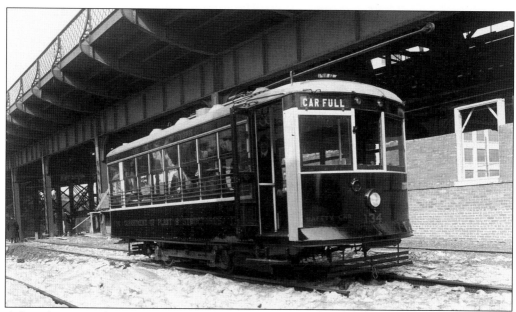

A brand-new single-truck Birney car—just delivered to the New York City Department of Plant and Structures for use on the Bridge Local service on the Williamsburgh Bridge between Manhattan and Brooklyn—stands in front of a carbarn still being built under the shadows of the bridge. These cars will initiate the local service but will soon be spelled by newly renovated, larger double-truck cars. The displaced Birneys will shortly move to another Department of Plant and Structures rescue operation, the recently terminated rail service of the Staten Island Midland in the borough of Richmond.

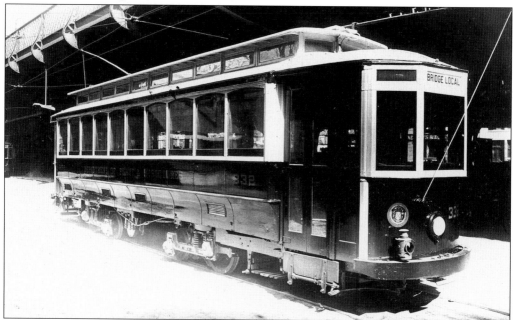

The Department of Plant and Structures purchased a fleet of cars from the Second Avenue Railroad and rebuilt them for service as Bridge Locals. Newly delivered car No. 332 shows off its new owner's lettering and livery.

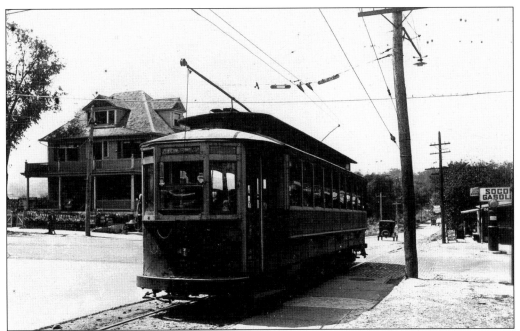

The Department of Plant and Structures also operated the moribund Staten Island Midland line until a new owner could be found. Cars were shifted between locales by ferries owned by the department. Car No. 318 is shown in the wilds of New York's outpost borough of Richmond in 1923.

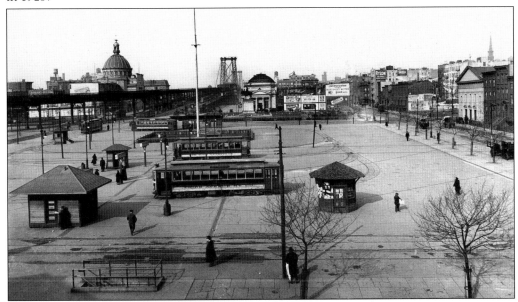

Streetcar service on the Williamsburg Bridge in 1917 was extremely heavy. The Brooklyn Rapid Transit operated many lines from its Manhattan underground Delancey Street terminal via the tracks on the south side of the bridge, while the New York Railways and Third Avenue Railway operated conduit-powered cars on the north tracks. The latter companies' cars ran around this elaborate looped complex at the Brooklyn end while the former had a virtual mirror-image complex south of the bridge.

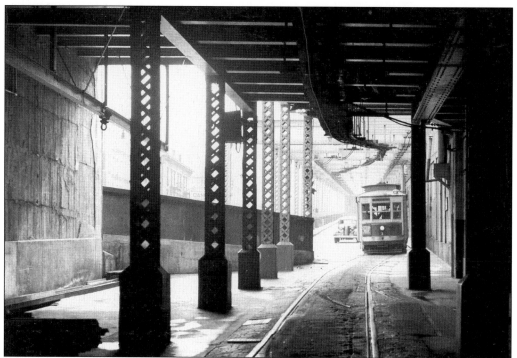

Long Island City's Steinway Lines operated with leased Third Avenue Railway equipment. Here, a standard Third Avenue convertible enters the stygian darkness of the Queensborough Bridge's underground Manhattan terminal at East 59th Street. At one time, cars from the New York and Queens County, the Manhattan and Queens, and the Third Avenue Railway all crossed this bridge. (Courtesy Walter Kevil collection, from Krambles-Peterson Archive.)

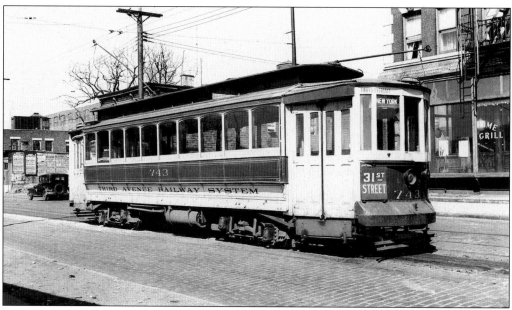

In Steinway service, Third Avenue Railway System's car No. 743 carries the destination sign reading, "New York," as did cars of all Queens lines crossing the Queensborough Bridge.

Third Avenue Railway System's car No. 7 in Steinway is in service on the "outrigger" tracks on the Queensborough Bridge. Note the conduit rail, derelict since 1919.

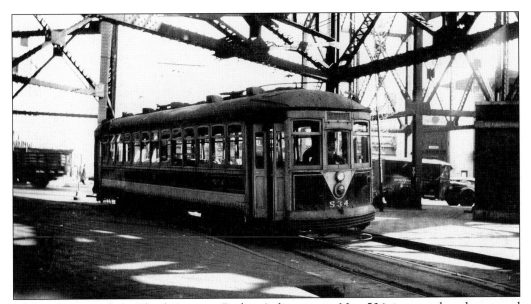

Although painted in Third Avenue Railway's livery, car No. 534 is owned and operated by the Queensboro Bridge Railway. This car originally ran on the Manhattan Bridge Three Cent Line.

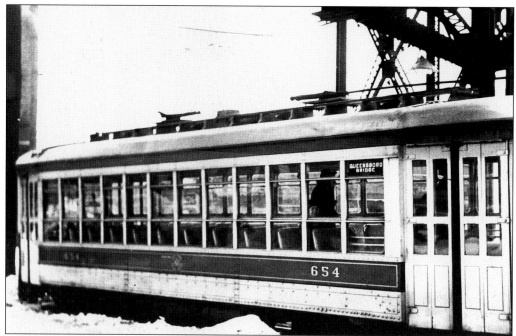

While their former Manhattan Bridge Three Cent Line cars were being built for exclusive bridge service, the Queensboro Bridge Railway leased a number of the Third Avenue Railway's newest cars, such as No. 654, as temporary replacements.

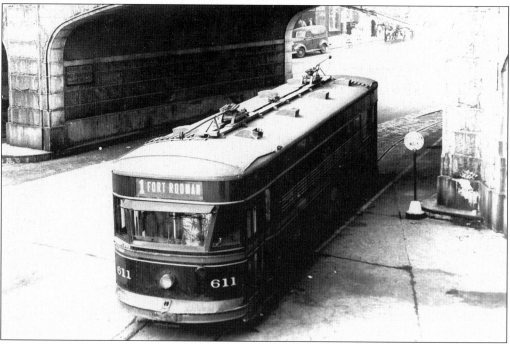

In 1948, with their older cars literally falling apart on them, the bridge railway purchased a group of modern cars from the Union Street Railway of New Bedford, Massachusetts, the first of which is shown being delivered in its original colors.

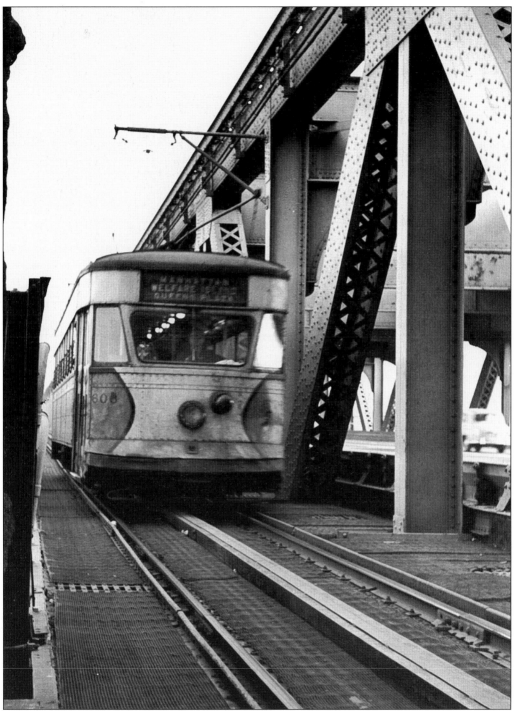

Queensboro Bridge Railway car No. 606 is in service on the bridge. Cars of this line were variously lettered for the Queensboro Bridge Railway, the Queensborough Bridge Railway, and the Queensboro Bridge Railroad. Seen here is a closeup of Queensboro Bridge car No. 606 at the Welfare Island stop. The open latticework metal platform served as the station.

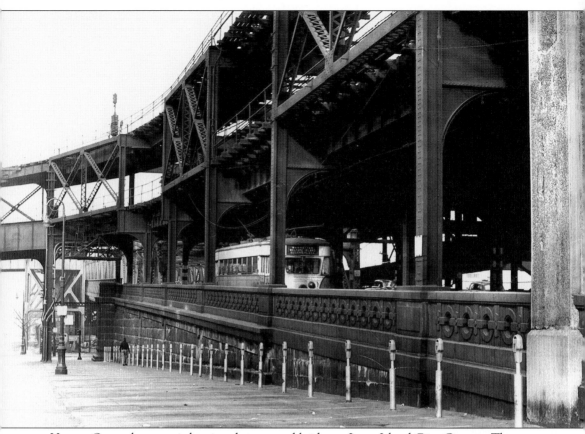

Here, a Queensboro car is leaving the east end bridge at Long Island City, Queens. The cars ran about another three blocks before terminating at a small pavement-protected street terminal. In just a few days, this service will be terminated and New York will have lost its last streetcar line.

Nine

THE BROOKLYN BRIDGES

In construction sequence, the next East River bridge to be built was the Williamsburg Bridge, which reached Manhattan at bustling Delancey Street. Built in the same mode as the Manhattan Bridge with two sets of streetcar tracks separated from the vehicular roadways, the Williamsburg structure also had a set of rapid-transit tracks. The street railway tracks in this case were slightly different than the Manhattan Bridge tracks. On the south side of the bridge was the Bridge Local, originally jointly owned by the New York Railways and the Brooklyn Rapid Transit. The Brooklyn Rapid Transit was chosen to furnish and operate the cars. Later the Bridge Local was completely operated by the Brooklyn Rapid Transit when the New York Railways joined the Third Avenue Railway in running conduit lines on the north side of the bridge, which terminated at Brooklyn's Williamsburg Plaza at the east end of the bridge.

The Brooklyn trolley line extensions of the Bridge Local and the succeeding Brooklyn Rapid Transit terminated in an elaborate terminal located underground at the south side of Delancey Street. The New York Railways Company and Third Avenue Railway System lines continued within Manhattan as feeders to their local systems. The major difference between these operations and those on the Manhattan Bridge was that the Williamsburg lines offered transfer privileges. The Brooklyn Rapid Transit provided access to connecting Brooklyn trolley lines, while the New York Railways Company and Third Avenue Railway System cars transferred to their own Manhattan routes.

Until the building of the Williamsburg Bridge, downtown Brooklyn was centered around the Williamsburg downtown area. Once the bridge was complete, it marked the virtual end of ferry service from Williamsburg docks to Manhattan. In this case, however, the trolley terminals in Manhattan were set far enough beyond the East River to be reasonably unaffected except for the premature closing of the waterfront street railway facilities. Still, even with all of the potential street railway traffic, the Williamsburg Bridge car lines did not do well.

The Third Avenue Railway System and New York Railways Company quickly ended their money-losing services without replacement, and when the Bridge Local line suspended service, the New York City government decided that this service was imperative. So the city authorized their department of plant and structures who operated and maintained the city's bridges and municipal Staten Island ferry line to run a substitute trolley service on the south bridge tracks. This was New York City's first foray into operating municipal streetcar lines. The newly reconstituted Bridge Local service used a collection of rebuilt, ancient thirdhand large streetcars,

supplemented by a fleet of newly purchased single-truck Birney streetcars. After a short time, the city convinced the Brooklyn Rapid Transit to once again take over the bridge line and the DP&S moved their cars to Staten Island to keep the bankrupt Staten Island Midland trolley system afloat until they could get a private operator to run that system.

The last of the four major East River bridges was the Queensborough Bridge, which crossed from an underground terminal at 60th Street and Second Avenue in Manhattan, to Long Island City, Queens. Originally the line had two sets of street railway tracks—one set located outboard of the automobile lanes and the other sharing the vehicular space. Two different trolley companies originally crossed the bridge: the Manhattan and Queens and the New York and Queens County. Late in the second decade of the 20th century, the Third Avenue Railway extended their conduit-powered 42nd Street crosstown line to Queensboro Bridge Plaza in Long Island City, but they abandoned their franchise within seven years. The New York and Queens County company reorganized in the early 1920s and broke into two independent companies: the New York and Queens, which ran exclusively in eastern Queens county, and the Steinway Lines, which picked up the western Queens lines, including the transbridge route. Their bridge local line served a most unusual station—the municipal hospital complex on midriver Blackwell Island, later known as Welfare Island and now called Roosevelt Island. The island was connected to the outer world only by the bridge trolley line that linked the facility to the bridge via an "upside down" building whose enclosed elevator fed into the top floor known as "floor 1" and dropped to the intra-island road system at ground level at "floor 2." The Steinway local trolley had a formal station that connected to both of the outrigger tracks. Because of this connection, their line and its subsequent successor, the Queensboro Bridge Railway, outlasted all of the other trolley lines on the bridge and, in fact, became New York's last operating streetcar line, running until replaced by an aerial tramway on April 6, 1957.

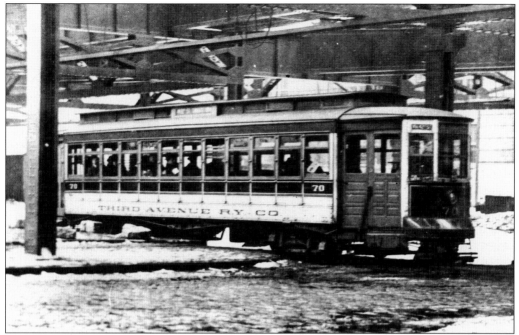

Between 1912 and 1919, the Third Avenue Railway's 42nd Street crosstown line had some cars continue over the Queensborough Bridge to Queens Plaza. Here conduit car No. 78 nears the end of its run in Long Island City. For over 40 years after the discontinuance of this service, the conduit rail remained.

When the New York and Queens County Railway was involved in building the "Steinway" tunnels between Queens and Manhattan in 1906, the New York Public Service Commission decreed that heavy, fireproof steel cars with end doors would be used. The New York and Queens never operated the tunnel in revenue service but used all 50 expensive-to-run cars for many years in light suburban service.

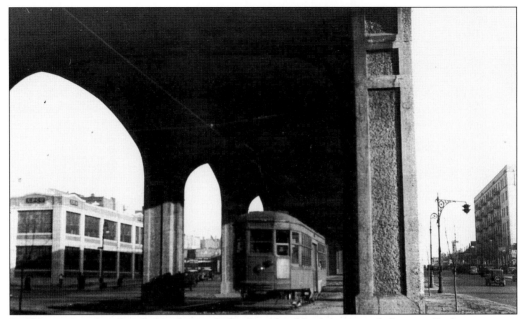

In the area nearer the Queensborough Bridge, the Manhattan and Queens Railway ran on private right-of-way under the newly opened Flushing (No. 7) subway line.

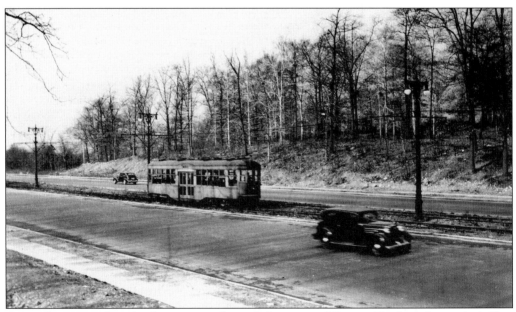

On grade separated track, along a sparsely settled section of Queens Boulevard in today's Kew Gardens area, the Manhattan and Queens Railway ran a suburban line that connected Jamaica to Manhattan via the Queensborough Bridge.

Ten

THE EAST RIVER
CROSSINGS

Today there are nine subway tunnels connecting Brooklyn and Queens with Manhattan, but one is unique. In 1887, the New York and Long Island Railroad was chartered to construct a rail line to connect Long Island to Manhattan Island. The connection was to be a railroad tunnel. One of the investors in the new company was William Steinway, president of his namesake piano company and very involved with Long Island's transportation situation. Building accidents ruined the New York and Long Island Railroad, and 10 years passed before a new company, August Belmont's Interborough Rapid Transit, renewed the project. However, instead of main line railroad trains, the new tunnel would carry the streetcars of his newly acquired New York and Queens County Railway. The dangerous tunneling took over two years to complete, but on September 24, 1907, a New York and Queens County Railway trolley car made the first trip from Long Island City to a new station located beneath Grand Central Terminal. It was the only car ever to make the trip because New York politics interceded and stopped the project once again. In 1913, the line was again resurrected, but this time it was to be a segment of the IRT'S dual contract Flushing-Astoria service. It is now in service, much rebuilt, as the New York City Transit Authority's No. 7 Flushing line.

But it was another privately built tunnel that provided the most critical loss of the East River ferry passengers. In 1910, the Pennsylvania Railroad's magnificent Pennsylvania Station opened. It was connected to the Pennsy's lines, west by the double-tracked trans-Hudson tunnel. As part of the operating strategy, those tunnels also continued east under the East River, permitting the Long Island Rail Road's electric trains an all rail trip from most of Long Island directly into the heart of Manhattan. This diminished the importance of the Long Island Rail Road's Hunters Point waterfront terminal and ferry service to Manhattan's 34th Street ferry slip. The latter ferry slip had been so important that six street railway tracks served the complex, together with an elevated spur that connected directly with the Second and Third Avenue elevated lines. The loss of the transriver ferry passengers ultimately brought an end not only to the ferry service but also to the elevated line and finally the street railways.

SUMMARIES AND CONCLUSIONS

To give a realistic overview, the street railways of Manhattan died due to a number of reasons.

First, the commercial center around southern Manhattan simply had too many lines to support their traffic. So one after another, the weaker lines were abandoned. The more viable properties were folded into the larger systems.

Second, once the subways were built, the extremely dense population of the lower East Side dispersed outward, primarily along the new rapid-transit routes and diminished the need for local street transport. In fact, by being settled in new areas, the Bronx, outer Brooklyn and suburban Queens, the movement encouraged the building of new trolley lines.

Next, the lines operating over the East River bridges realized much too late that the shuttle services they offered were quickly overcome by the cheap, frequent, rapid, and widespread transportation offered by the now comprehensive rapid-transit network. There simply was not a sufficient passenger base to support passengers whose only transport need was to cross a bridge. And where there was demand, it was inbound toward New York and the locals tended to favor their local companies like the Brooklyn Rapid Transit trolleys rather than the "outsiders" from Manhattan, like the New York Railways and the Third Avenue Railway System. Also, especially in Manhattan, the rapid-transit lines quickly decimated the north–south street railway traffic base. Once the elevated lines were electrified and the subway lines were constructed, the use of surface rail for longer runs rapidly evaporated.

Also, the reduced use of ferry service forecast the end of the many street railway lines designed solely to distribute the ferry passengers within the downtown commercial district. The Hudson River ferry lines were viable for a much longer period. The commuters from in-close New Jersey communities did abandon the local trolleys feeding the ferries for either one-seat bus lines using the vehicular tunnels or invested in their own automobiles. On the other hand, those railroads that carried commuters or that terminated their long-distance trains at the New Jersey Hudson shore ran their own ferries almost until the end of their passenger services.

As the gross and, especially, the net revenues of the existing street railways decreased, their management became much more aware of the high cost of maintaining their underground conduit power transmission system. It was discovered that operating and maintaining the conduit system cost as much as eight times the expense of drawing power from overhead wire. This raised the "break-even" point for operating conduit lines even closer to the level where abandonment and bus substitution made economic sense. That figure became very closely watched by the operators and their stockholders.

Automobile traffic, which had started out as a minor annoyance to the street railways, now had became the controlling factor in the utilization of roadway and street space. Once it became so obvious, local politics came into the picture.

So the New York City municipal government officially decided that the image of the streetcar was "old fashioned" and that its use inhibited the traffic flow on the city's streets. And to them, obviously, the motor bus was the panacea, the surface transport of the future. Thereupon, the city embarked on a long-range program to rid the city of the "ancient, clanking, slow, traffic-inhibiting" streetcars and instituted the use of arterial one-way street traffic to favor the use of motor vehicles. After years of trying, they finally accomplished this aim, and in 1957, the very last streetcar ran in the city of New York.

The city surface system is now homogenized and all encompassing, but considering its antecedents, it certainly is dull.

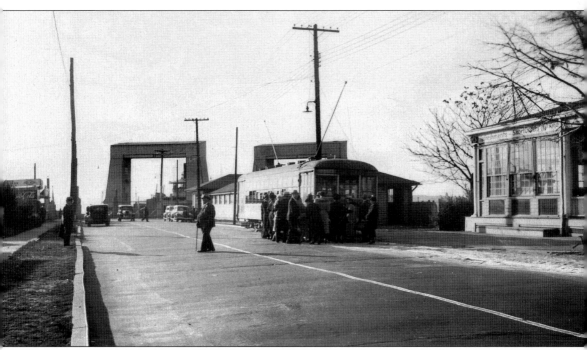

The New York and Queens Railway College Point line terminated at the ferry terminal at College Point on Long Island Sound. Note the float bridges in the background.

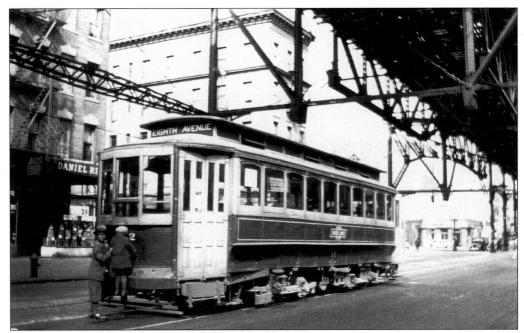

One of the great outdoor sports in older New York was "hitching" a ride on the outside of a streetcar. Two nonrevenue passengers are shown riding on a Green Lines car on Eighth Avenue under the Ninth Avenue elevated structure. Their dapper get-up suggests that these two riders were on their way to church that Sunday morning.

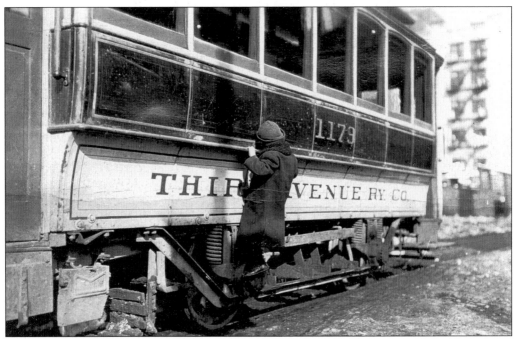

A much smaller and more foolhardy free rider is attached to Third Avenue Railway's battery car No. 1179 in Manhattan's lower East Side around 1915.

A former Second Avenue Railroad car sits forlornly in the middle of the Hunts Point scrapping yard, serving as an office while its sisters are destroyed for their salvageable metal parts.

Unwanted Third Avenue Railway cars, having outlived their usefulness, are burned for their scrap in the Mount Vernon trash pit.

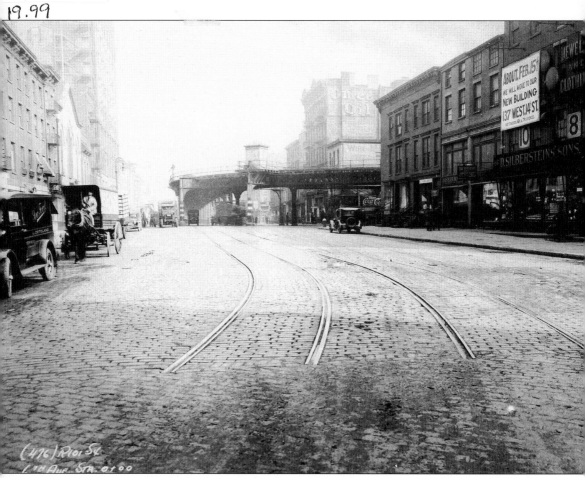

A harbinger of things to come, unused tracks of the former New York Railways Sixth Avenue ferry storage battery line lead to nowhere, soon to be a common sight in Manhattan and ending, once and for all, in 1957, when the Queensboro Bridge Railway abandoned New York's final streetcar line. (Courtesy Vincent Seyfried collection.)